BLACK AMERICA SERIES

RICHMOND

VIRGINIA

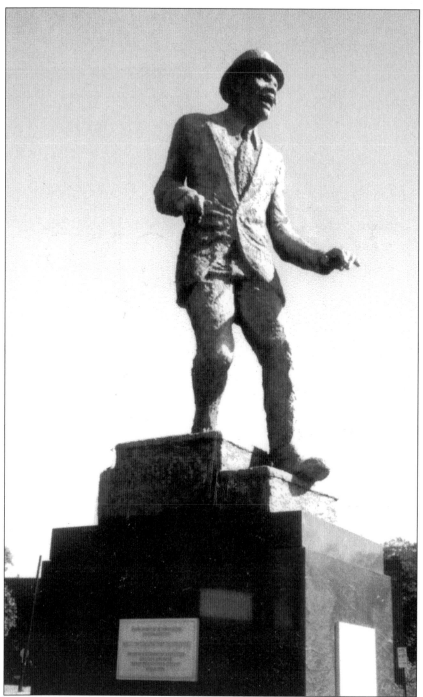

At the intersection of Chamberlayne Parkway, Adams Street, and Leigh Street is a monument to native son and pioneering entertainer Bill "Bojangles" Robinson. Besides being an extraordinary dancer, he also starred in several movies with Shirley Temple and others. In the early 1930s Mr. Robinson paid over $1,000 to have a stoplight erected at this busy intersection to protect the local school children. (Photo by Elvatrice Belsches.)

BLACK AMERICA SERIES

RICHMOND
VIRGINIA

Elvatrice Parker Belsches

ARCADIA

Published by Arcadia Publishing,
an imprint of Tempus Publishing, Inc.
2 Cumberland Street
Charleston, SC 29401

Printed in Great Britain.

Library of Congress Catalog Card Number: 2001094875

For all general information contact Arcadia Publishing at:
Telephone 843-853-2070
Fax 843-853-0044
E-Mail sales@arcadiapublishing.com

For customer service and orders:
Toll-Free 1-888-313-2665

Visit us on the internet at http://www.arcadiapublishing.com

I dedicate this book to my heroes and parents, Ernest and Mary Parker,

whose faith, guidance, love, and exemplary lives have been God's gift to our

family and legions of students. I also dedicate this work to my husband,

Alton Belsches Jr.; my brothers, Ernest Parker, Carlton Parker, Darryl Parker,

Chevell Parker, and their families for their continuous love and support.

CONTENTS

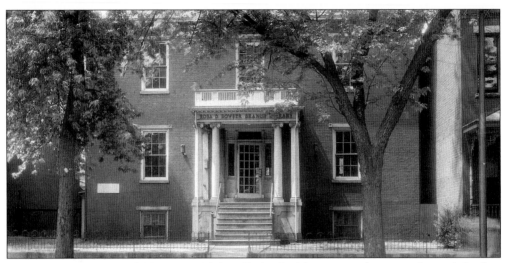

Built in 1832 by successful baker Addolph Dill, this building at 00 Clay Street housed the first African-American branch of the Richmond Public Library. Named for pioneering educator Rosa Dixon Bowser, the branch was moved to this location in the early 1930s. It is now the home of the Black History Museum and Cultural Center of Virginia, Inc. (Courtesy of Library of Congress.)

ACKNOWLEDGMENTS

First and foremost, I would like to thank God for planting the seed for this project and rendering everything needed to complete it unto me. Special thanks go to Teresa Roane, director of Archival and Photographic Services at the Valentine Richmond History Center. Her encyclopedic knowledge of the holdings are an invaluable asset to us all. Special thanks also go to Lucious Edwards Jr., curator of the Virginia State University Archives, whose immense knowledge of his holdings yielded many rare sources of information. Very special thanks go to historian Dr. Edgar Toppin for a reading of the manuscript. Many thanks are also in order to Charles Bethea and the staff of the Black History Museum and Cultural Center of Virginia. They provided immense support and encouragement in addition to access to their outstanding holdings. I am also extremely grateful to the staffs of the Virginia Historical Society, the L. Douglas Wilder Library of Virginia Union University, the National Park Service, Maggie L. Walker National Historic Site, the Library of Virginia, the Virginia Department of Historic Resources, the Virginia Commonwealth University Special Collections, Library of Congress, and the National Archives.

Very special thanks are in order to the following individuals who contributed their stories, assistance, and photographs for this project: Martha Thompson, Theodore S. Holmes, Dr. William Ferguson Reid, Benjamin Ross and the Sixth Mount Zion Baptist Church, Daniel Perkins Jr. and the First African Baptist Church, Alice Calloway, J.W. Robinson Horne, Carolyn Washington Brown, Dr. LaVerne Byrd Smith, Richard Waller, Phyllis Dance, Lelia Kirksey, Karen Butler, Doris Friend, Robbin Friend, Mary Alexander, Atty. Robert Alexander, Thomas Mitchell, Atty. Oliver W. Hill Sr., Dr. and Mrs. Benjamin Lambert III, the Holy Rosary Catholic Church, Francis Williams and the Third Street Bethel A.M.E. Church, Edward C. Byrd, Alton Belsches Sr., Cornelia B Ryan, the St. Philip's Episcopal Church, Lynda Sharpe Anderson and the Metropolitan Business League, Earle Taylor, Ray Bonis, and McEva Bowser. Last but not least, a special salute and thanks are in order to Dr. Francis M. Foster Sr., who is not only the undisputed authority of the history of African Americans in Richmond but a foremost authority on the history of African Americans in medicine as well.

INTRODUCTION

Richmond Virginia was established as a town in 1742, became the seat of state government in 1779, and was incorporated as a city in 1782. African Americans have played integral roles in the development of the city since its inception.

Because of the unsurpassed scholarship of the late historian Dr. Luther Porter Jackson and his publication, *Free Negro Labor and Property Holding in Virginia, 1830-1860*, we are provided with invaluable information regarding free blacks who prospered in Richmond and in other major urban areas of the state from the late 1700s to 1860. During this period, many blacks were able to obtain their freedom by plying trades that allowed them to not only purchase their freedom but to become property holders as well. Black slaves and freedmen dominated the ranks of carpenters, blacksmiths, barbers, and carriage drivers. Although the freedmen and the enslaved of this period and beyond labored under oppressive and restrictive laws, emancipation unleashed an entrepreneurial spirit that brought universal prominence to the African Americans of Richmond.

Richmond has borne the monikers, "Harlem of the South," "The Birthplace of Black Capitalism," and "Black Wall Street." These are due in large part to the historic district known as Jackson Ward. During the latter 1800s and beyond, a large percentage of Richmond's African-American population resided in this ward and it became home to many pioneering businesses and entrepreneurs. We are deeply indebted to the work of Dr. D.A. Ferguson, a pioneering dentist and Richmond resident. His pictorial work *Souvenir Views: Negro Enterprises & Residences, Richmond, Virginia* was published in 1907. Dr. Ferguson, one of the first licensed African-American dentists in Richmond, provides us with extraordinarily rare glimpses of African-American businesses at the turn of the 20th century in Richmond, and many of the photographs from his rare publication are reproduced in this volume.

Richmond's Jackson Ward would also become an entertainment mecca with such personalities as Lena Horne, Cab Calloway, Duke Ellington, Ella Fitzgerald, and of course noted native son Bill "Bojangles" Robinson, among countless others, gracing its venues. Because of its extraordinary architecture and its entrepreneurial and cultural legacies, Jackson Ward has become one of the largest National Landmark Historic Districts associated with African-American culture and history in the country, according to the National Park Service.

Finally, a study of the legacy of African Americans in Richmond yields not only a veritable treasure chest of Virginia's history but our nation's history as well. The accomplishments of key figures of this community have impacted the world in areas as diverse as entertainment, sports, education, medicine, civil rights, the military, politics, and business. It is hoped that this publication will serve as a primer in honoring and illuminating the lives of the many who have endured and persevered. May we endeavor to learn from their travails and triumphs.

Lest We Forget!

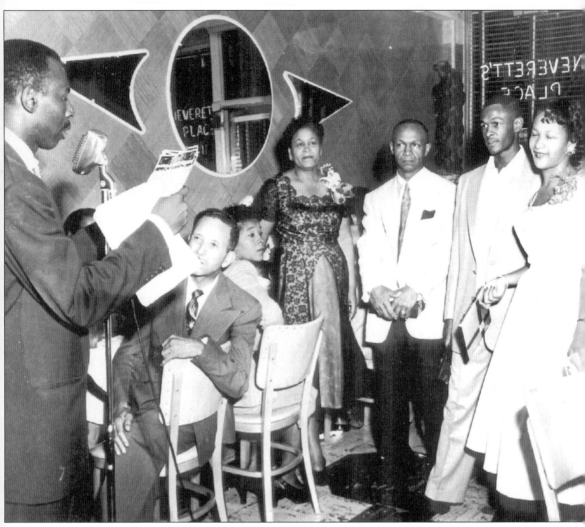

This photo was taken during the 1950s grand opening of Neverett's Place within the African American–owned Eggleston Hotel, located at Second and Leigh Streets in Jackson Ward. Pictured standing from left to right are disk jockey Allen Knight, Sally Eggleston, her husband Neverett Eggleston Sr., their son Neverett Eggleston Jr., and their daughter Jane Eggleston. (Courtesy of the Black History Museum and Cultural Center of Virginia.)

One
THE EARLY YEARS

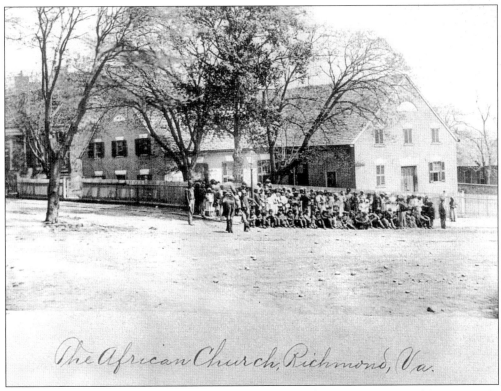

The African Church, Richmond, Va.

Pictured here are the First African Baptist Church and some of its members in 1865. This church, which was originally organized around 1780 as the white First Baptist Church, was erected around 1802 and located at the corner of Broad and College Streets. Freed blacks and slaves were allowed to worship in the galleries. In 1841 with the black members outnumbering the white members by over four to one, the white members decided to leave and erect the First Baptist Church at Twelfth and Broad Streets. In 1841 the First African Baptist Church was organized with the remaining African-American members from the First Baptist Church. This building was torn down in 1876 and the congregation rebuilt at the same location. (Courtesy of the Valentine Richmond History Center.)

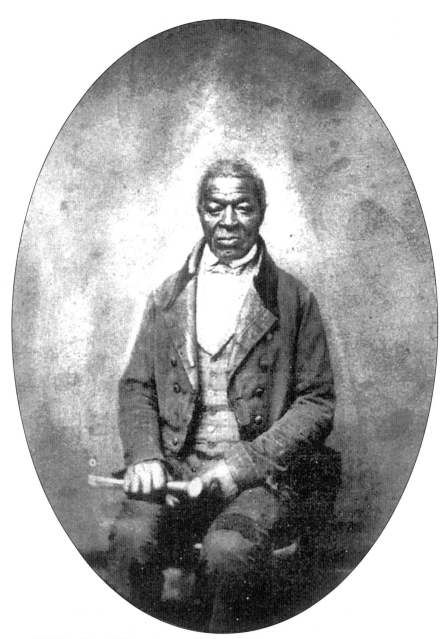

Born around 1780 in King William County, Virginia, Gilbert Hunt was brought to Richmond to learn the carriage-making business, according to his memoirs. He later became a prosperous blacksmith who gained his freedom in 1829. He is best known, however, for his heroic actions during a major theater fire that occurred on December 26, 1811 in Richmond. A local physician, Dr. James McCaw, endeavored to save patrons by leading them to a window where they were dropped into the waiting arms of Mr. Hunt. Although 72 patrons perished in the fire, several were saved by the heroic efforts of these two men. In 1823 his heroic efforts were again called upon as he rushed to a fire at the state penitentiary and assisted others in leading over 200 inmates to safety. Mr. Hunt was also a founding deacon of the First African Baptist Church. (Courtesy of the Valentine Richmond History Center.)

Pictured here is an 1858 page entry from the actual minute book of the Burying Ground Society of Free People of Color. According to *The Negro in Virginia*, in 1815 this group purchased a plot of land for $240 and raised over $700 for a burial fund. It is strongly believed that this early organization served as a blueprint for the many benevolent societies that would later appear among African Americans in Richmond. Several members listed above were prosperous free black property owners. Various land deeds, tax records, and city directories show that Director Benjamin W. Judah (listed as B.W. Judah) was a successful shoemaker who owned several houses and lots. Richard C. Hobson (listed as R.C. Hobson), was a prosperous barber at the American Hotel. (Courtesy of the Black History Museum and Cultural Center of Virginia.)

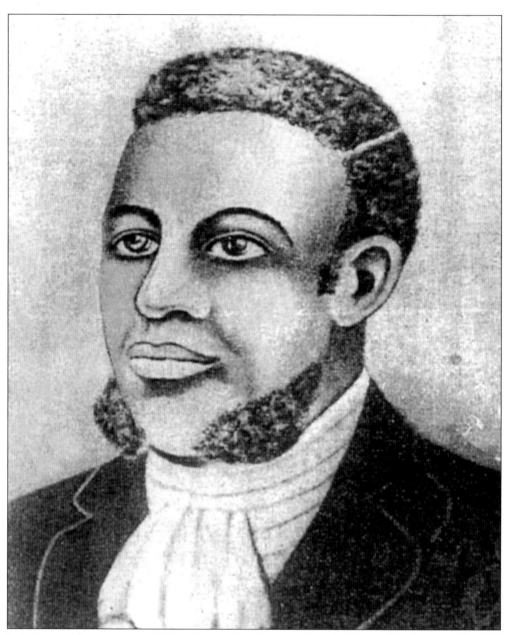

Lott Cary was born around 1780 in Charles City County, Virginia. He was hired out by his slave owner as a laborer in a tobacco warehouse in Richmond where he excelled at his duties and rose to the rank of shipping clerk. He was able to sell, for his own benefit, waste tobacco and was later able to purchase his freedom and that of his two children. Cary later joined the First Baptist Church and became licensed to preach by that body. He began to feel compelled to somehow spread the Gospel in Africa. In 1815 he, Colin Teague, and several others at First Baptist organized the Richmond African Baptist Missionary Society. With their backing, further assistance, and an appointment from the General Baptist Missionary Convention, Lott Cary, Colin Teague, and several others set sail in 1821 for Sierra Leone, becoming two of the first African-American missionaries from America. (Courtesy of Daniel Perkins Jr.)

At A. Meeting of a number of free people of colour
of the City of Richmond — at the first baptist meeting
house — for the purpose of ascertaining among them those
who were disposed to embark to the; american Colony
in africa the ensuing fall or the first opportunity
~~that may~~ that may offer — and after prayer by Brother
Robt Dandridge and a short explanation by Bro
Isaac Vines the following persons came forward
being Recomended according to the request of the board of
managers of the Colonization Society and had their
names enroled — as follows —

Hembrey Tampkins	}	Cooper
Polley Tampkins &	} 11	
Eight Children		
Mary Tampkins		
Samuel L Jones	}	Shoemaker
Jane Jones — &	} 6	
four Children —		
David Login ✻	}	Trader
Maria Login &	} 5	
three Children		
Nat Anderson — — 1		Blacksmith
polley Lewis — — — 1		Wife of Jack ___ Lewis
William Tyree — 1		Waiter
Samuel Jackson — 1		Miller

Test Wm Reynolds. Clk
March 7th 1824

✻ not Recomended

Above is a list of free people of color in Richmond who met at the First Baptist Church in March of 1824 and expressed a desire to emigrate to Liberia. All but one were recommended for the journey. (Courtesy of the Virginia Historical Society.)

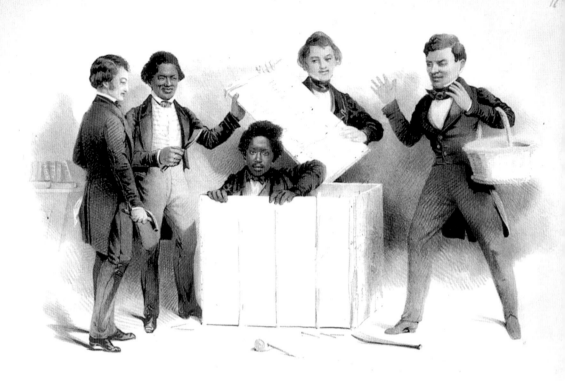

THE RESURRECTION OF HENRY BOX BROWN AT PHILADELPHIA.
Who escaped from Richmond Va in a Box 3 feet long 2½ ft deep and 2 ft wide

According to his memoirs, Henry "Box" Brown was born in about 1850 in Louisa County, Virginia and brought to Richmond to work in a tobacco factory. He later met his wife, Nancy, who would ultimately be sold four times locally before ending up with an unscrupulous owner who sought to extort money from Brown by threatening to sell his wife and children. Finally, on one fateful morning in 1848, Brown received word after he left their rented house in town for work that his wife and children had been taken to an auction house and sold. He was further informed that they were being housed in a slave jail and if he wanted to see them on the next day he could stand on a particular street on the route that they would take on their journey out of town. On the next day Brown stood by hoping for a glimpse as the slave coffle of about 350 men, women, and children approached. Reportedly, they had all been purchased by a Methodist minister and were headed to North Carolina. The men and women had ropes upon their necks and chains upon their arms. He subsequently spotted his wife and they joined hands and walked in silent sorrow for approximately four miles before having to part. Forlorn after losing his family, Brown was ready to answer the roll call to freedom. In March of 1849, with the assistance of others who were agents on the Underground Railroad, he had himself nailed into a wooden box that was three feet and one inch deep, two and a half feet long and two feet wide. He was then shipped via carriage, railway, and steamship to Philadelphia, a journey that took over 26 hours. Finally at daybreak on the next morning, Henry "Box" Brown was liberated by awaiting agents in Philadelphia. (Courtesy of Library of Congress.)

INFIRMARY

OF THE

MEDICAL COLLEGE,

For White Persons and Slaves,

CORNER OF MARSHALL AND COLLEGE STREETS.

This establishment is furnished with every convenience for the comfortable accommodation of the sick, and every facility for their Medical and Surgical treatment. The patients are under the charge of the PROFESSORS OF THE COLLEGE, who visit the wards daily, and are aided in their management by an efficient corps of assistants.

WHITE PERSONS who may desire it, will be furnished with PRIVATE ROOMS, where they will enjoy every comfort and attention.

The accommodations for SLAVES are ample, and the attention of owners and hirers of negroes, both in the city and country, is invited to the advantages offered by this Institution, especially in

SURGICAL CASES

NO CASE OF SMALL POX,

or any other INFECTIOUS DISORDER, or of INSANITY, can be admitted.

The charges, (including Board, Medical Attendance, Nursing, and Medicines,) are as follows:

White Patients,...$6 per week.
" " in private rooms,..................................$7 to $15
Slaves and other Colored Patients,.......................$5

For any period less than one week, (except in private rooms,) $1 per day, provided that the aggregate shall not exceed the charge for a full week.

In addition to the above regular rates, a small fee is charged for SURGICAL OPERATIONS, varying from $2 to $30, according to their importance and difficulty.

☞ All charges payable on the removal of the patient.

This is an advertisement from an early city directory for the Medical College of Virginia. Free and enslaved African Americans could also be seen at the Main Street Hospital for Slaves, which was located near the corner of Main and Twenty-sixth Streets, and Bellevue Hospital, which was located at Broad and Twenty-second Street.

AUCTION SALES.

BY DICKINSON, HILL & CO., AUCTS.

FIFTY NEGROES.—This Day, at 10 o'clock will be sold 50 likely Negroes, consisting of Men Boys and Girls, and Women and Children.
DICKINSON, HILL & CO., Auct's

BY BETTS & GREGORY, AUCTS.

TWENTY NEGROES.—This day, at 10 o'clock we will sell 20 likely slaves.
BETTS & GREGORY, Aucts.,
Franklin Street.

BY HECTOR DAVIS, AUCT.

50 NEGROES.—This day, at 10 o'clock, will be sold 50 likely slaves
HECTOR DAVIS, Auct.

BY PULLIAM & CO., Auctioneers.

25 NEGROES—We will sell Twenty-five likely NE-GROES To-Day, at 10 o'clock.
PULLIAM & CO., Auct'rs,
Odd Fellows' Hall
N. B.—House Servants, Cooks, Washers and Ironers, for sale privately.
P. & CO.

BY DAVIS, DEUPREE & CO., AUCTS.

18 NEGROES.—We will sell THIS MORNING, at 9½ o'clock, eighteen likely Slaves.
DAVIS, DEUPREE & CO.,
Odd Fellows' Hall, corner Mayo and Franklin sts

This group of advertisements, found in the July 16, 1860 edition of the *Richmond Enquirer*, is but a small depiction of the massive interstate slave trade carried on from Richmond during the antebellum period. The abolishment of the legal transatlantic slave trade became effective on January 1, 1808. This, coupled with the subsequent expansion of the United States and migration by planters into the Cotton Kingdom, fueled a dramatic rise in the domestic slave trade. Richmond became one of the largest slave-trading centers in the South. (Courtesy of the Library of Virginia.)

A partially printed receipt documents the sale of an enslaved man named Bob. The use of these documents became prevalent during the 1840s in Richmond. (Courtesy of author's collection.)

A written agreement was issued for the hiring of a slave named Joe, the property of J.M. Burton, by the Tredegar Iron Works for a period of one year. Tredegar Iron Works was one of the most well-known iron foundries of the South. Richmond mirrored other urban industrialized cities of the South in that nearly one half of the enslaved population were hired out. With its many flour mills, tobacco warehouses, and iron factories, Richmond came to extensively rely upon slave hires for labor. Many of these slaves had to find their own housing and subsequently began to establish communities. More than a few who exceeded their allotted tasks were able to earn money and later purchase their freedom and that of their families. (Courtesy of the Virginia Historical Society.)

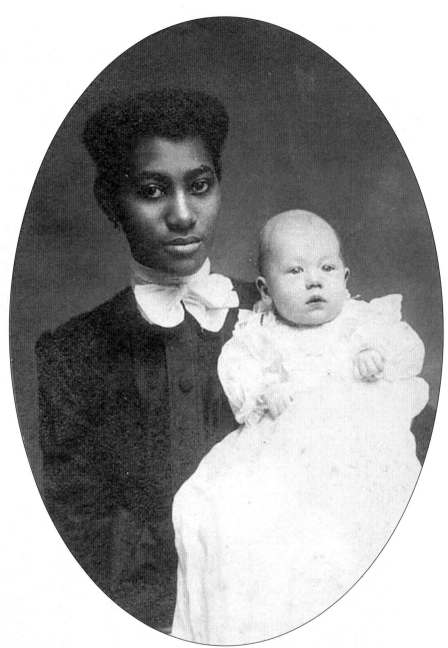

Although the early life of Mary Elizabeth Bowser is not well documented, what is known is that she was placed as a servant presumably during the Civil War within the household of Confederate Pres. Jefferson Davis. It was here that she reportedly became privy to conversations involving military strategies. Although she was never suspected, reportedly because of her docile and indifferent demeanor, Bowser used her intelligence and uncanny memory to recite and relay much of what she heard to operatives in a Union spy ring. Her vital contributions on behalf of the Union were officially recognized in 1995 with her posthumous induction into the Military Intelligence Corps Hall of Fame at Fort Huachuca, Arizona. (Courtesy of James Chambers, US Army Deputy, Office of the Chief, Military Intelligence.)

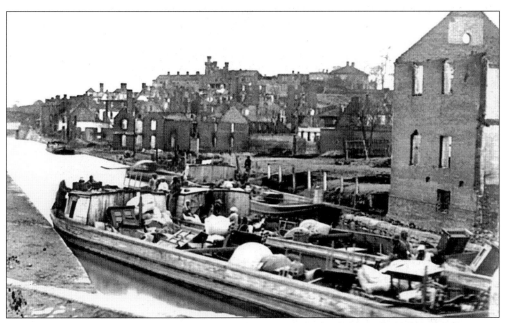

This photograph shows African-American refugees on a boat with household belongings. It was taken after the fall of Richmond c. April–June 1865. (Courtesy of Library of Congress.)

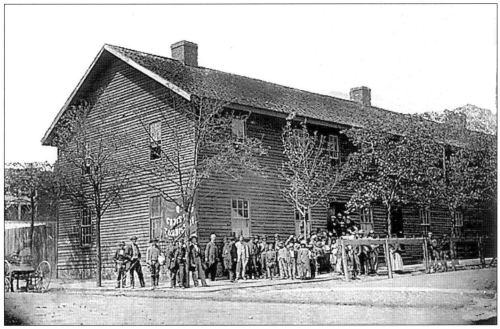

This photograph shows a group, including African-American men, women, and children, in front of the headquarters of the U.S. Christian Commission in Richmond, Virginia, in 1865. The commission provided relief to both soldiers and the freedmen. Reportedly this building also housed the Freedmen's Bureau and was located at Broad and Tenth Streets. (Courtesy of the National Archives at College Park.)

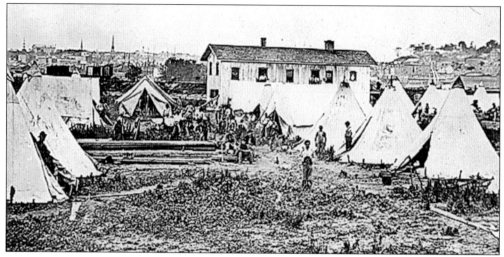

This is a photograph of a contraband camp at Richmond, Virginia, in 1865. Although the term "contraband" was generally used in reference to confiscated physical property and livestock, in 1861 Union Maj. Gen. Benjamin F. Butler began to use the term in reference to slaves who had escaped into the Union occupied area at Fortress Monroe near Hampton, Virginia. As the number of refugees increased, several locations in the state served as encampment sites for the freedmen. They were generally supplied with food, clothing, shelter, and wages in exchange for performing assigned work tasks for the Union. (Courtesy of the National Archives at College Park.)

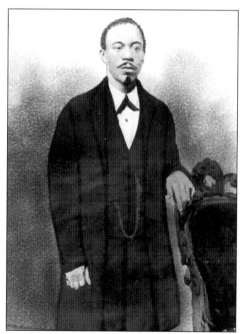
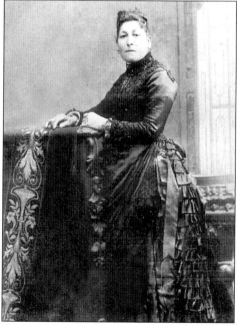

James W. Washington (1839–1884) served as a corporal in Company B, Light Artillery, 2nd Regiment of the United States Colored Troops during the Civil War. Prior to enlisting in 1864, he married Miss Priscilla Anderson on September 4, 1862, at the First African Baptist Church in Richmond. (Courtesy of Carolyn Washington Brown.)

Two
THE CRADLE OF
BLACK CAPITALISM

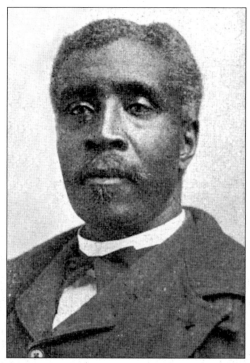

Rev. William Washington Browne (1849–1897) was the founder of the United Order of True Reformers. This benevolent society, which began as a temperance society, grew to become one of the largest African-American business enterprises in America at the turn of the 20th century. In March of 1888 the Reformers received a charter from the State of Virginia to open a bank. The Savings Bank of the United Order of True Reformers became the first bank chartered by African Americans in America. The Reformers' empire would grow to include a weekly newspaper, an industrial and mercantile division, a hotel, a home for the elderly, and real estate in several states. The organization would grow to have tens of thousands of members. (Courtesy of *Twenty-five Year History of the United Order of True Reformers*.)

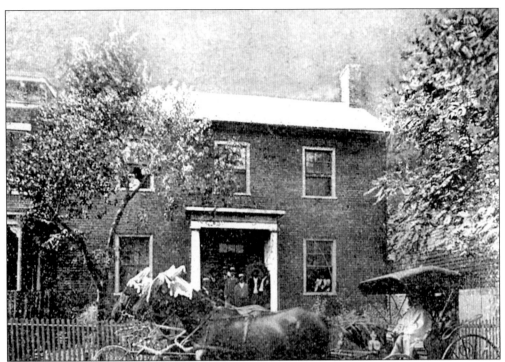

The initial location of the True Reformers' Bank was in the home of Rev. William Washington Browne. This house is located at 105 West Jackson Street in Richmond. (Courtesy of the *Twenty-five Year History of the United Order of True Reformers*.)

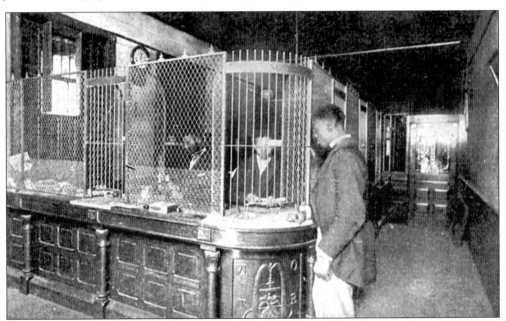

This is an interior photograph of the bank after it moved into the True Reformers' Hall and Bank in the 600 block of North Second Street. (Courtesy of the *Twenty-five Year History of the United Order of True Reformers*.)

This is a *c.* 1909 photograph of the True Reformers' Hall and Bank Building, which was located in the 600 block of North Second Street. The building's contractor was George Boyd, a noted African-American builder in Richmond who also built the Baker School and the Sixth Mount Zion Baptist Church. (Courtesy of the *Twenty-five Year History of the United Order of True Reformers*.)

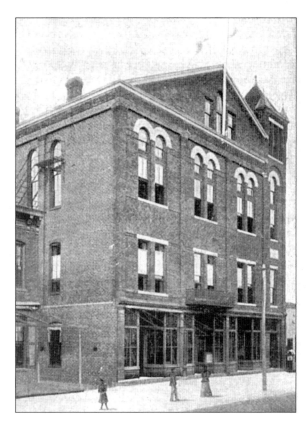

The Reformers' Grocery Store was located on the corner of Sixth and Clay Streets. (Courtesy of *Souvenir Views*.)

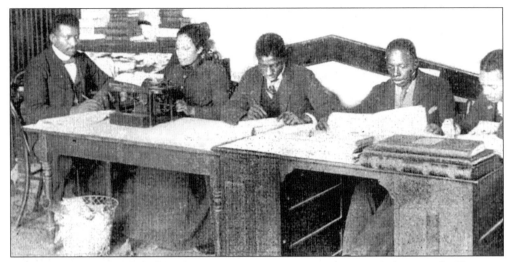

Some of the editing staff at *The Reformer* newspaper are seen in a *c.* 1905 photograph. (Courtesy of author's collection.)

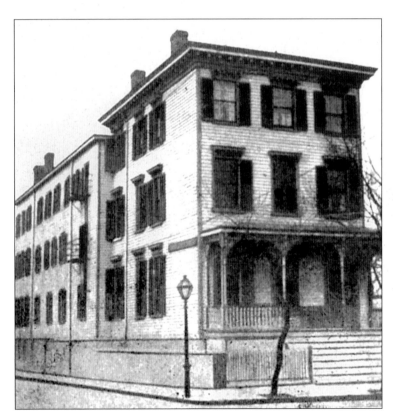

The Hotel Reformer, reportedly described by Booker T. Washington to be one of the finest African-American hotels in the South, was located at Sixth and Baker Streets. It could accommodate over 100 guests. (Courtesy of *Souvenir Views.*)

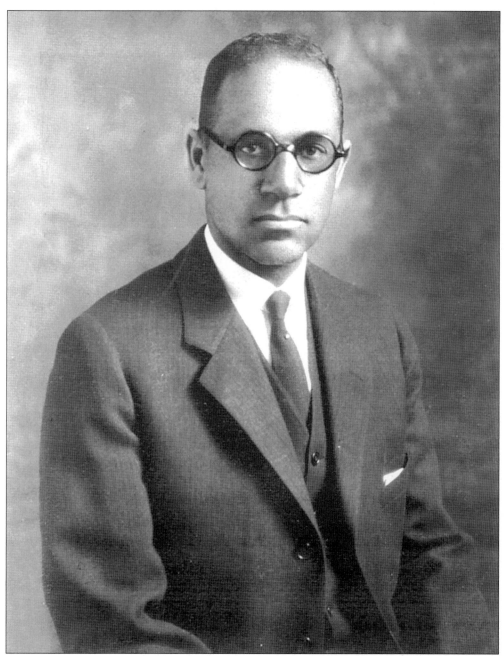

Charles T. Russell (1875–1952) was one of the first licensed African-American architects in the City of Richmond and in the State of Virginia. He attended Hampton Institute and returned to his hometown of Richmond to embark upon a career that would lead him to design several buildings for African-American businesses. His projects included the St. Luke Penny Savings Bank, the Richmond Beneficial Building, the Second Street Savings bank, and the major remodeling of the Sixth Mount Zion Baptist Church. He was also president of the National Builders Association and president of the Security and Realty Corporation. (Courtesy of the National Park Service, Maggie L. Walker National Historic Site.)

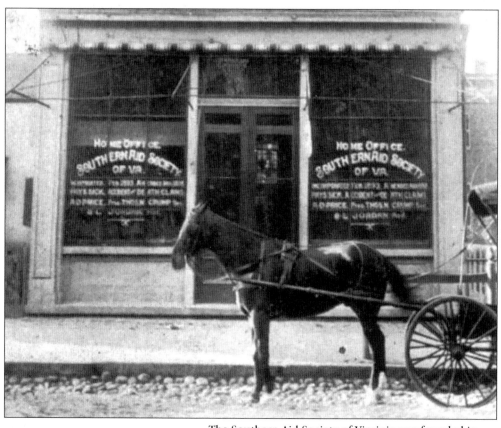

The Southern Aid Society of Virginia was founded in 1893. This society is thought to be the first chartered insurance company organized and run by African Americans in the South. The president of the company when this picture was taken, *c.* 1907, was A.D. Price. (Courtesy of *Souvenir Views*.)

The United Aid Insurance Company, seen here *c.* 1907, was chartered in 1894 and was located at 312 East Broad Street. (Courtesy *Souvenir Views*.)

The home office of the Richmond Beneficial Insurance Co. is seen in 1907. It was organized in 1894 by John T. Taylor and others. (Courtesy *Souvenir Views*.)

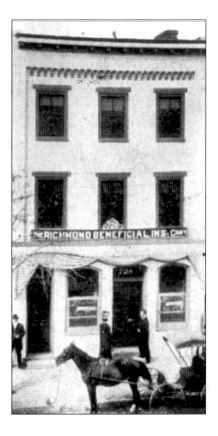

This is a picture of the Home Office the American Beneficial Insurance Company. It was organized in 1902 by founding president Rev. W.F. Graham. (Courtesy *Souvenir Views*.)

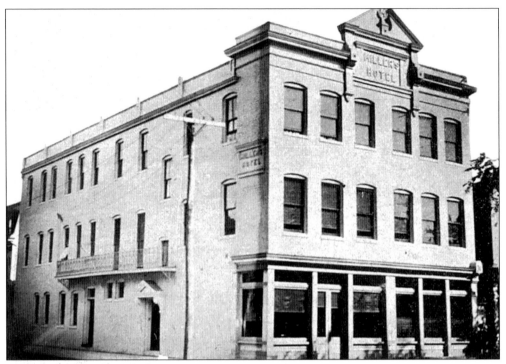

This was the hotel of William "Buck" Miller in 1907. Miller's Hotel was located at Second and Leigh Streets. (Courtesy *Souvenir Views*.)

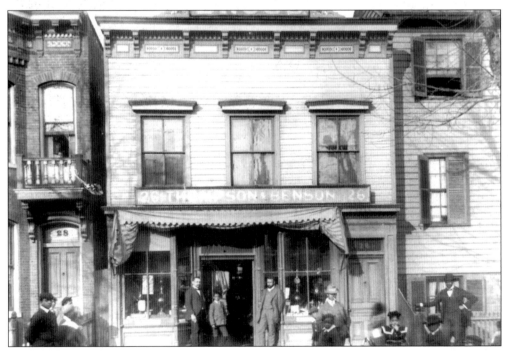

The Thompson and Benson Pharmacy, shown here *c.* 1900, was located on Leigh Street. (Courtesy Library of Congress.)

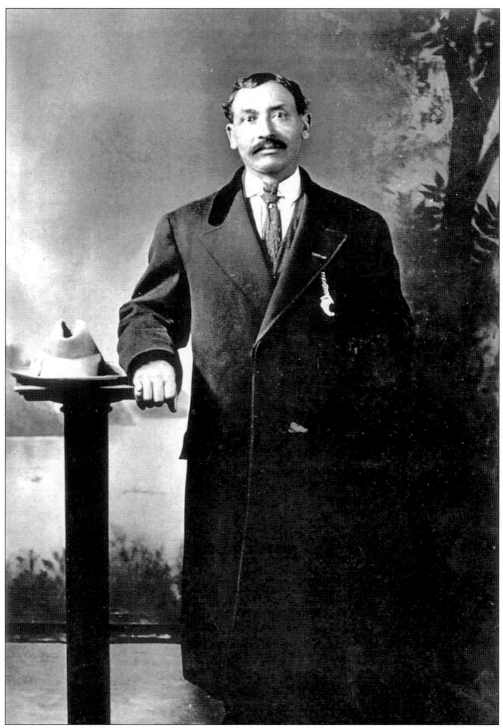

Born around 1873, Marcellus Carrington Waller founded Waller Jeweler & Sons in 1900. Today, over 100 years later, his grandson Richard Waller and other descendants have continued the successful legacy of this company. (Courtesy of Richard Waller Jr.)

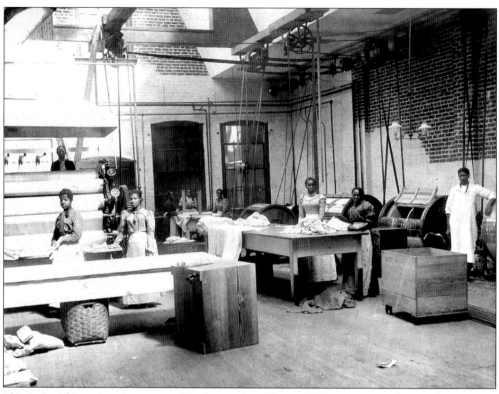

This is the African American–owned Lexington Laundry, *c*. 1900. (Courtesy Library of Congress.)

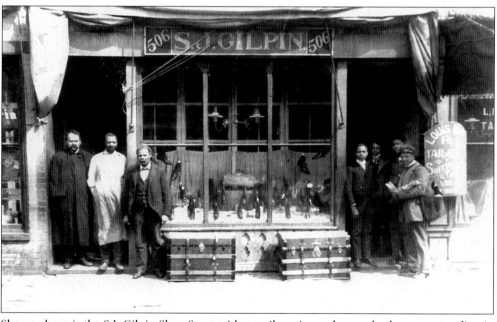

Shown above is the S.J. Gilpin Shoe Store with a mail carrier and several other men standing in the doorway, *c*. 1900. (Courtesy Library of Congress.)

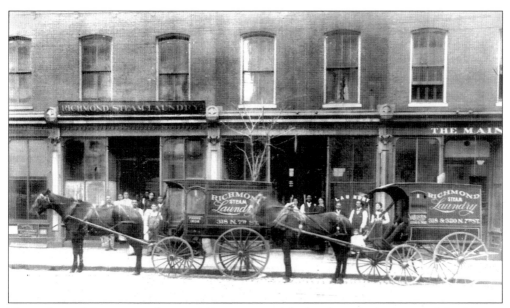

The Richmond Steam Laundry, *c.* 1900, was owned by brothers G.W. Bragg and D.P. Bragg. According to the publication *Souvenir Views*, the company owned three delivery wagons, employed 30 people, and had a plant valued at $20,000. (Courtesy Library of Congress.)

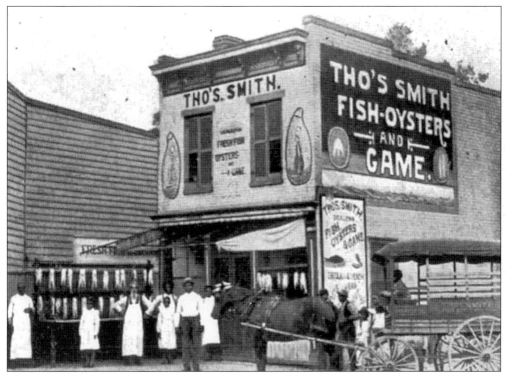

Thomas Smith's Fish, Oysters, and Game is shown here, *c.* 1907. (Courtesy *Souvenir Views.*)

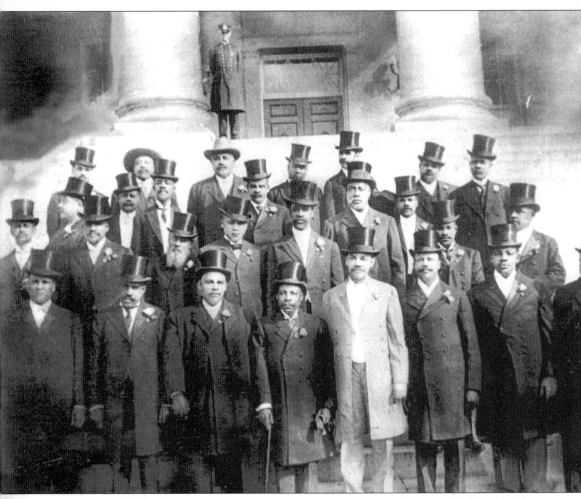

This photograph shows the group of Richmond's African-American leaders who met with Pres. William Howard Taft at the State Capitol in Richmond in 1909. They are, from left to right, (first row) John T. Taylor, Henry Mallory, Rev. W.L. Taylor, George St. Julien Stephens, John Mitchell Jr., Thomas M. Crump, Thomas H. Wyatt, and W.P. Burrell, (second row) Edwin Archer Randolph, E.W. Brown, W.M.T. Forrester, Joseph Pollard, Rev. W.T. Johnson, O.H.B. Bowser, M.D., and W. Isaac Johnson; (third row) A.D. Price, R.T. Hill, Emmett C. Burke, J.E. Jones, D.D., Rev. Evans Payne, E.F. Johnson, and B.F. Turner; (fourth row) Wm. H. Hughes, M.D., Col. Giles B. Jackson, Rev. W.F. Graham, J. Alexander Lewis, M.D., Rev. T.H. Lee, and Rev. Z.D. Lewis.

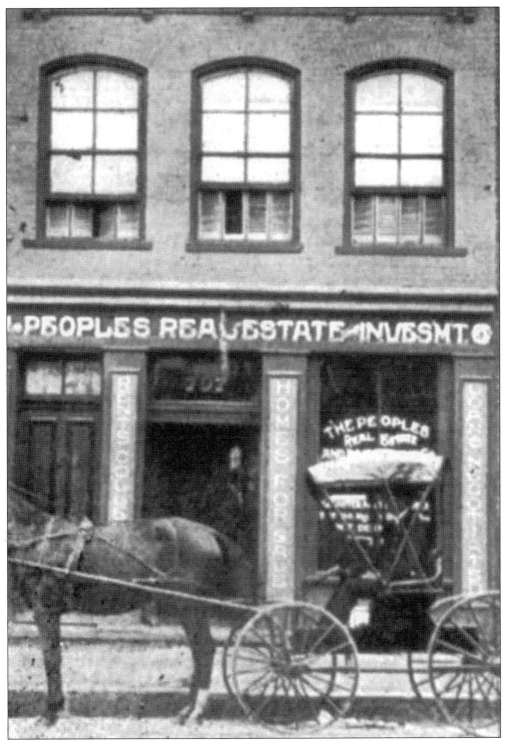

Pictured above is the People's Real Estate & Investment Co. *c.* 1907. It was located at 717 North Second Street. (Courtesy of Souvenir Views.)

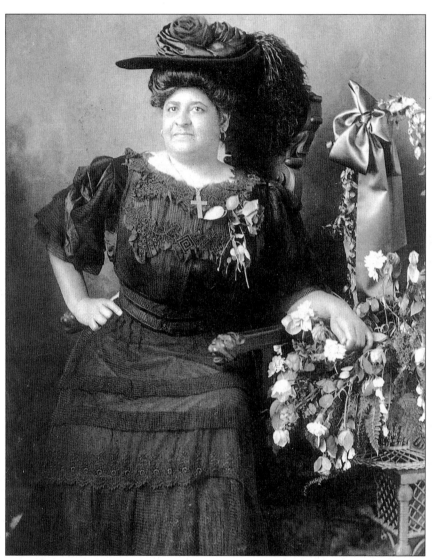

Maggie L. Walker (1867–1934) was born to a freed African-American mother and a white abolitionist father within the Van Lew Mansion. Mrs. Walker would rise from humble beginnings to become the first woman to found and become president of a chartered bank in America. This bank opened its doors in 1903 as the St. Luke Penny Savings Bank. Mrs. Walker (then Maggie Mitchell) joined the International Order (I.O.) of St. Luke as a teenager. This benevolent society was started in Baltimore in 1867 by Mary Prout, and its purpose was to provide sick and death benefits. In 1899 Mrs. Walker was elected to the highest office of the Order, Right Worthy Grand Secretary, and proceeded to transform the Order into one of national prominence. During her tenure, the I.O. of St. Luke's membership grew to over 100,000 in at least 22 states. In addition to founding the bank, she also founded the *St. Luke Herald*, a weekly newspaper. She was not simply an entrepreneur of the highest magnitude but also a faithful member of the First African Baptist Church and one who championed the rights of minorities and women. She was a valued consultant and member of many local and national organizations. This photograph was taken by the African American–owned Browns' Studio in Richmond. (Courtesy of the Valentine Richmond History Center.)

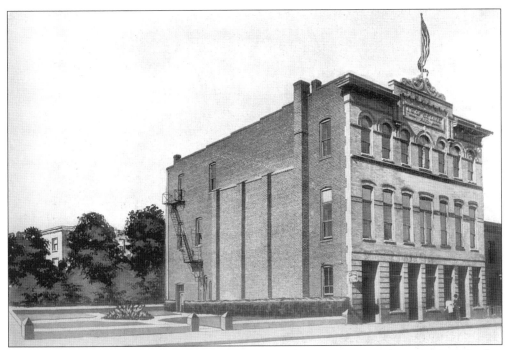

This is the former Hall of the I.O. of St. Luke. Built in 1902, it is located in the 900 block of St. James Street. It also housed for a short time the St. Luke Penny Savings Bank. (Courtesy of the National Park Service, Maggie L. Walker National Historic Site.)

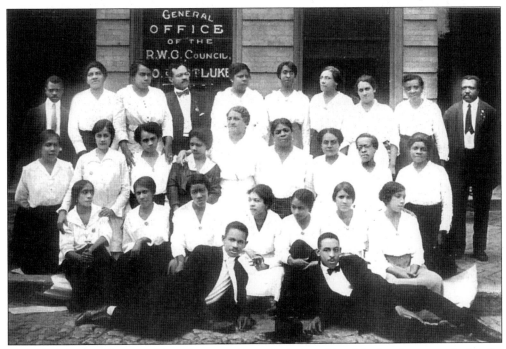

The office force of the I.O. of St. Luke poses for a picture outside of the headquarters during the early 1900s. (Courtesy of the National Park Service, Maggie L. Walker National Historic Site.)

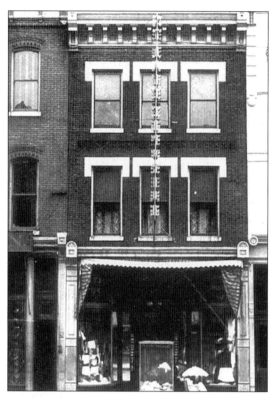

The St. Luke Emporium, the department store owned by the Order, was located at 112 East Broad Street. It temporarily housed the bank until one was built in 1911. (Courtesy of the National Park Service, Maggie L. Walker National Historic Site.)

The St. Luke Penny Savings Bank moved to a new building in 1911 at the corner of First and Marshall Streets. This new building was designed by African-American architect Charles T. Russell. (Courtesy of the National Park Service, Maggie L. Walker National Historic Site.)

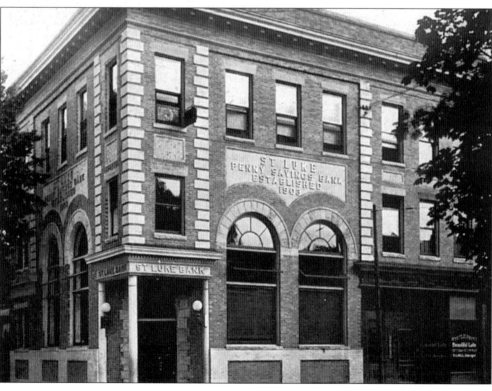

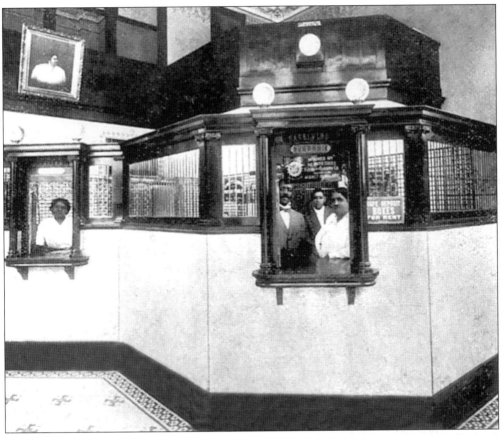

Maggie L. Walker and others pose in the interior of the St. Luke Penny Savings Bank. The bank was renamed the St. Luke Bank and Trust in 1923 and later merged with the Second Street Savings bank in 1930 to form the Consolidated Bank & Trust Company. (Courtesy of the National Park Service, Maggie L. Walker National Historic Site.)

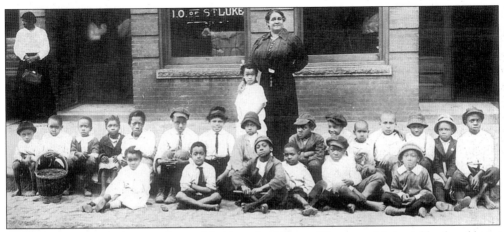

Maggie L. Walker is pictured in front of the St. Luke Offices with some of the neighborhood boys. (Courtesy of the National Park Service, Maggie L. Walker National Historic Site.)

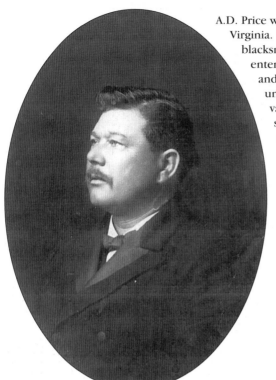

A.D. Price was born about 1860 in Hanover County, Virginia. He apprenticed into the trades of blacksmithing and wheelwrighting. He later entered the livery and undertaking business and became one of the most successful undertakers in the South. In addition to his vast real estate holdings, Price was also a supplier of stock to African-American undertakers in Virginia, Georgia, and the Carolinas from his warehouse in Richmond. (Courtesy of the Black History Museum and Cultural Society of Virginia.)

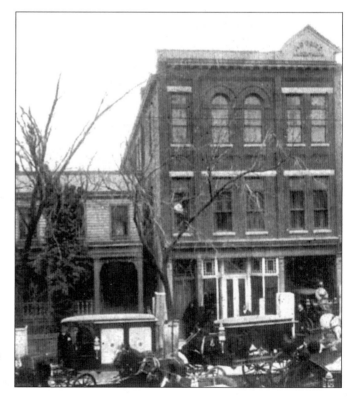

The A.D. Price Funeral Home is seen on Leigh Street *c.* 1907. The successful legacy of this establishment is being kept alive today by proprietors Mr. and Mrs. Fenton Bland Jr. (Courtesy of *Souvenir Views.*)

The Nickel Savings Bank, pictured here *c.* 1907, was located on the corner of Twenty-ninth and Leigh Streets. This building is still standing. It also had a branch within The Richmond Planet building at 311 North Fourth Street. (Courtesy of *Souvenir Views*.)

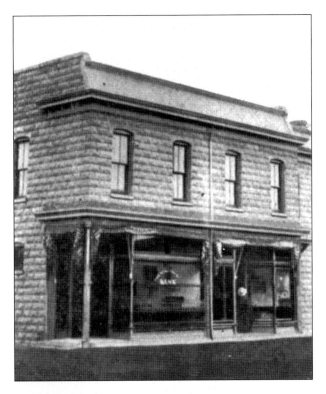

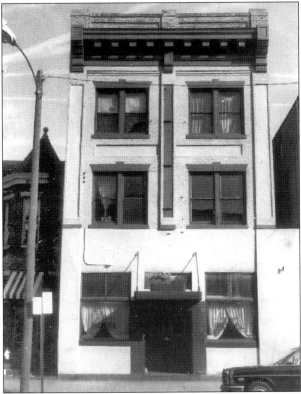

The Commercial Bank and Trust Company , established in 1920, was located in this building at 529 North Second Street. It later merged with the Consolidated Bank & Trust Company in 1931. This building was later home to Slaughter's Hotel, considered by many to be one of the finest African American–owned hotels in the South. This photo was taken in 1987 and this building has since been demolished. (Courtesy of the Virginia Department of Historic Resources.)

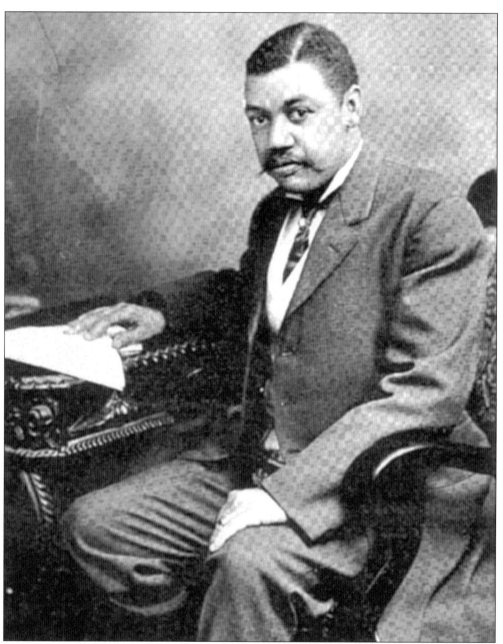

John Mitchell Jr. (1863–1929) was truly a renaissance man. He was elected to the Richmond City Council during Reconstruction and in addition served as the fearless editor and proprietor of *The Richmond Planet*, a weekly newspaper with a national circulation, for nearly 50 years. He founded and became president of the Mechanics Savings Bank in 1901 and was for a number of years the lone African-American member of the American Bankers Association. Mitchell also used his pen and paper to fight injustices at every turn. He campaigned tirelessly for the passage of an anti-lynching law and was one of the leaders of the boycott of the streetcars in Richmond when they became segregated in the early 1900s. (Courtesy of *History of the American Negro: Virginia Edition.*)

The Mechanics Savings Bank, founded by John Mitchell Jr., is captured in this *c.* 1907 photograph. It was located at 511 North Third Street. (Courtesy of *Souvenir Views.*)

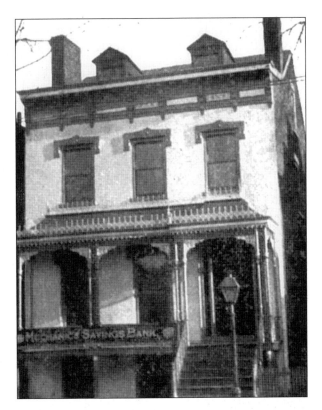

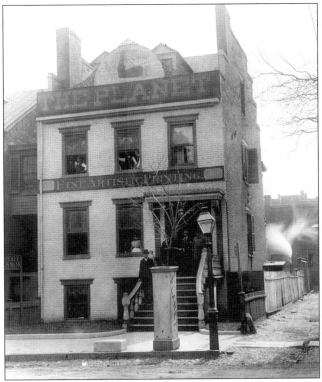

This photograph, taken around 1900, was displayed as part of the American Negro Exhibit at the Paris Exposition in 1900. It shows people posed on the steps of The Richmond Planet building, which housed the newspaper and job printing operations. The Nickel Savings Bank also had a branch located inside this building. (Courtesy of Library of Congress.)

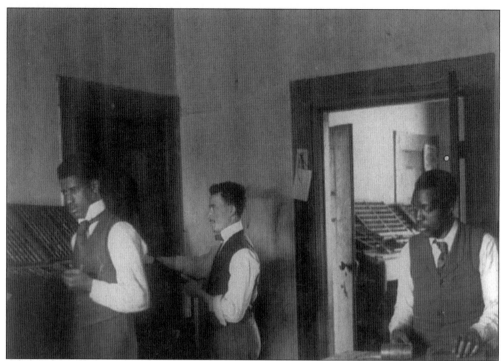

Employees are shown in the composing room of *The Richmond Planet c.* 1900. (Courtesy of Library of Congress.)

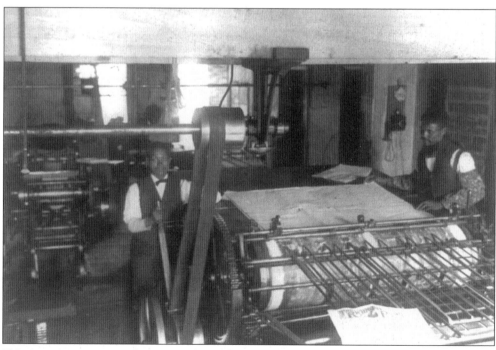

This image portrays employees in *The Richmond Planet*'s press room *c.* 1900. (Courtesy of Library of Congress.)

George W. Brown was a gifted photographer of the early to mid 1900s and the son of award-winning photographer George O. Brown. Together, with George W.'s sister Bessie W. Brown, they were collectively known as "The Browns." Their studio was located at 603 North Second Street, where they produced extraordinary portraits of families, dignitaries, and businesses for many decades. (Courtesy of the National Park Service, Maggie L. Walker National Historic Site.)

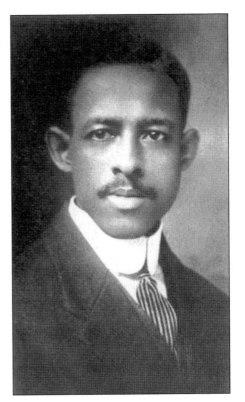

Col. Giles Jackson was one of the earliest African-American lawyers in the city. Credited with drawing up the charter for the Savings Bank of the United Order of True Reformers, Jackson is also believed to be one of the first African-American lawyers to argue before the Virginia State Supreme Court. Jackson is best remembered for procuring $100,000 from the United States Congress to finance the Negro Exhibit at the Jamestown Tricentennial Exposition in 1907. Jackson also served as first vice president of the National Negro Business League under founder and president Booker T. Washington. (Courtesy of the Black History Museum and Cultural Center of Virginia.)

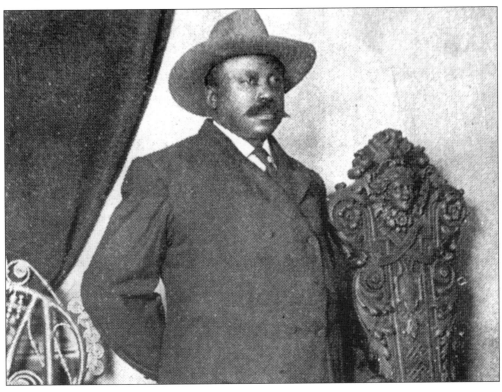

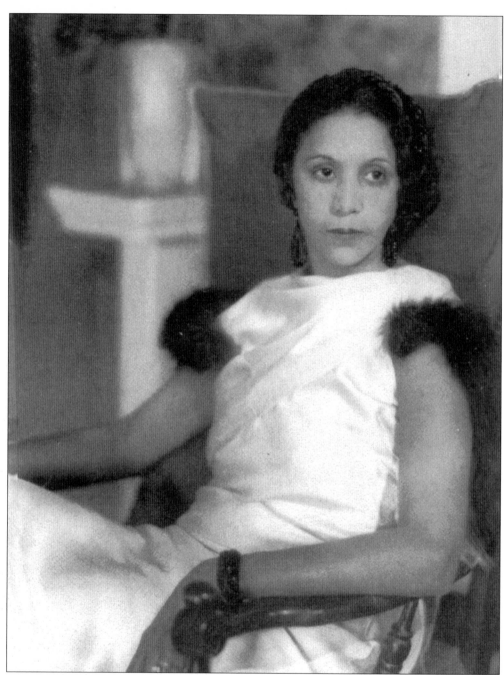

Madame Wilnet Chalmers was an extraordinary entrepreneur who never lost sight of the importance of service to the community. At a young age she left Richmond to study the techniques of Madame C.J. Walker and others. She then went on to open up several beauty schools of her own in Chicago, Houston, North Carolina, and Virginia. In addition to providing countless job opportunities and training to many others, Madame Chalmers volunteered her services to the war effort during World War II. In 2001, she was blessed to celebrate her 100th birthday. (Courtesy of the Black History Museum and Cultural Center of Virginia.)

Three
WORSHIP AND
WORSHIP LEADERS

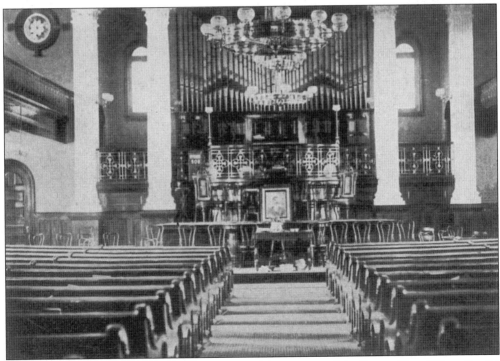

This is an early 1900s interior view of the beautiful sanctuary of the former First African Baptist Church, which was then located at the corner of Broad and College Streets. The beautiful chandeliers were donated by the Colgates of New York. This building is now a part of the campus of the Medical College of Virginia. (Courtesy of *Souvenir Views*.)

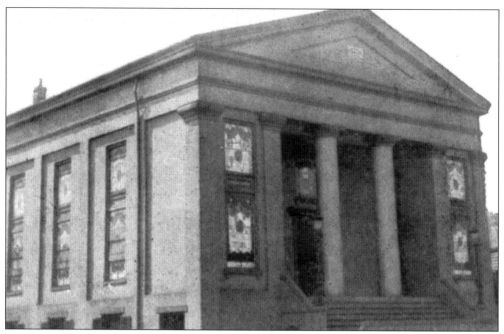

The Second Baptist Church was organized in 1846. The founding African-American members had been members of the white Second Baptist. This building, pictured *c.* 1907, was located on Byrd Street between First and Second Streets. (Courtesy of *Souvenir Views*.)

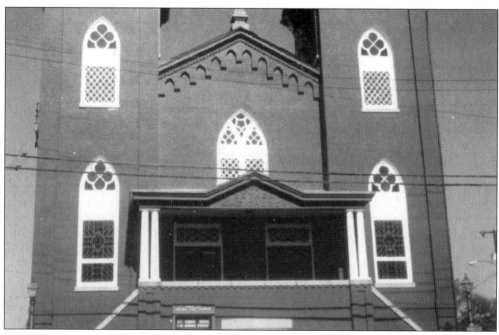

The Third Street Bethel African Methodist Episcopal Church was built in 1856. Located at 614 North Third Street, it is listed on both the Virginia Landmarks Register and the National Register of Historic Places. It is the second-oldest African Methodist Episcopal church in Virginia. (Photograph by Elvatrice Belsches.)

Rev. John Jasper (1812–1901) was the founding pastor of the historic Sixth Mount Zion Baptist Church. The church began in an abandoned Confederate horse stable on Brown's Island in 1867. Reverend Jasper achieved national acclaim for his sermon, "De Sun Do Move." After delivering it for the first time in 1878, he delivered it more than 250 additional times. He once was asked to deliver it before the Virginia General Assembly. African Americans and whites alike flocked to Sixth Mount Zion to hear the fiery orator. (Courtesy of the Sixth Mount Zion Baptist Church and Benjamin C. Ross.)

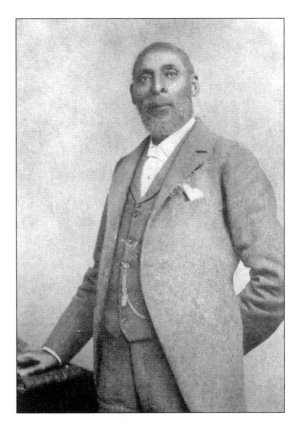

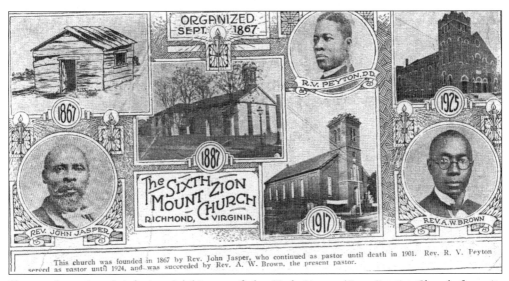

Shown above is a brief pictorial history of the Sixth Mount Zion Baptist Church from its beginning to about the late 1920s. (Courtesy of the Sixth Mount Zion Baptist Church and Benjamin C. Ross.)

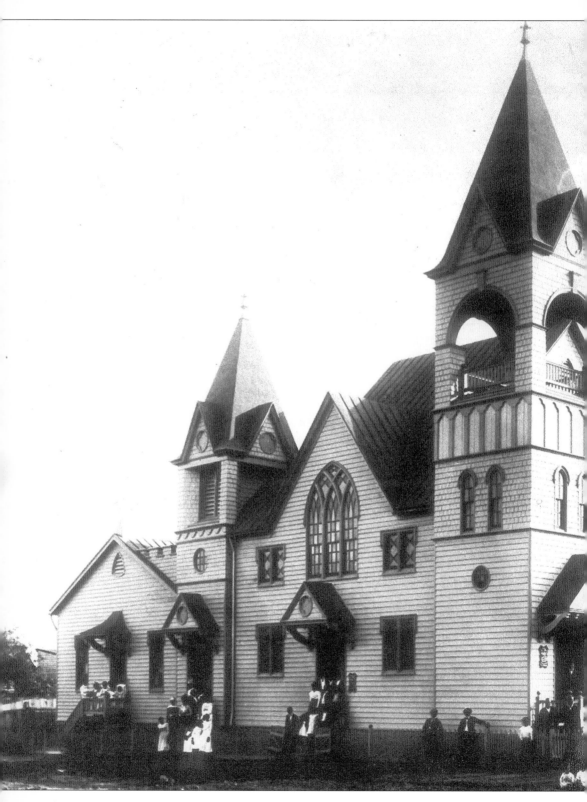

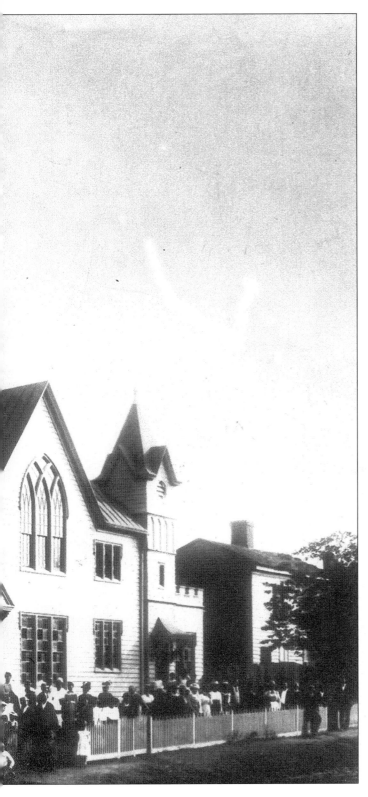

The Fountain Baptist Church, shown here around 1900, was located at the corner of Thirty-first and O Streets. (Courtesy of the Valentine Richmond History Center.)

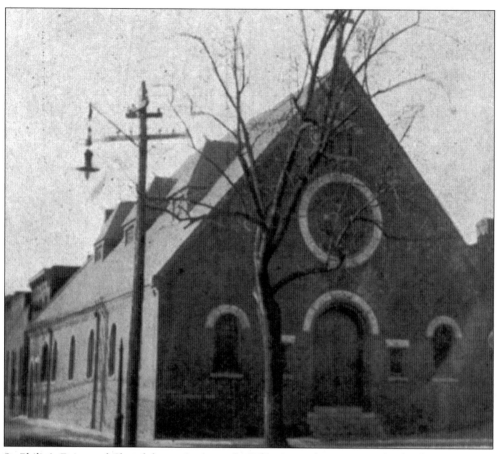

St. Philip's Episcopal Church began in the early 1860s. From the 1870s until 1959 the church was located at the corner of Leigh and St. James Streets. (Courtesy *Souvenir Views*.)

Ebenezer Baptist Church was organized in 1858 and has since been located on Leigh Street. It was home to one of the first public schools for African Americans after the formation of the Richmond Public School System around 1870. (Photograph by Elvatrice Belsches.)

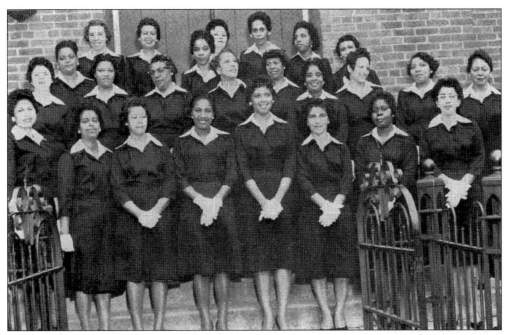

Pictured above are the Willing Workers Usher Board of Moore Street Missionary Baptist Church in 1962. (Courtesy of Mary E. Alexander.)

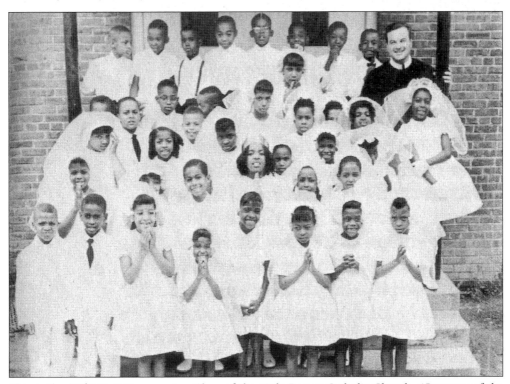

This is the 1962 First Communion Class of the Holy Rosary Catholic Church. (Courtesy of the Holy Rosary Catholic Church.)

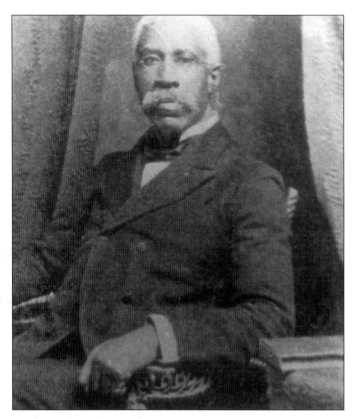

Rev. Dr. Anthony Binga Jr. (1843–1919) was the noted longtime pastor of what is now the First Baptist Church in South Richmond. His mother and father escaped slavery via the Underground Railroad and settled in Canada where he was born in 1843. He traveled to and settled in the Richmond area in the early 1870s and started a private school. Widely known for his scholarly sermons, Reverend Binga served with distinction as an educator and pastor for many years. (Courtesy of the Black History Museum and Cultural Center of Virginia.)

Dr. Gordon Blaine Hancock (1884–1970) served the Moore Street Missionary Baptist Church from 1925 to 1963. He was also a noted educator, sociologist, and journalist. Dr. Hancock was a sociology and economics professor at Virginia Union University for over 30 years, where he helped to organize the Torrance School of Race Relations at VUU and developed a race relations course that was thought to be one of the first of its type in the country. His syndicated column, "Between the Lines," was carried by over 100 newspapers. (Courtesy of the Black History Museum and Cultural Center of Virginia.)

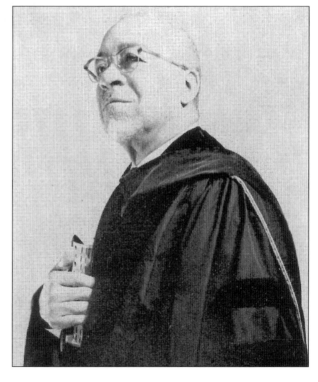

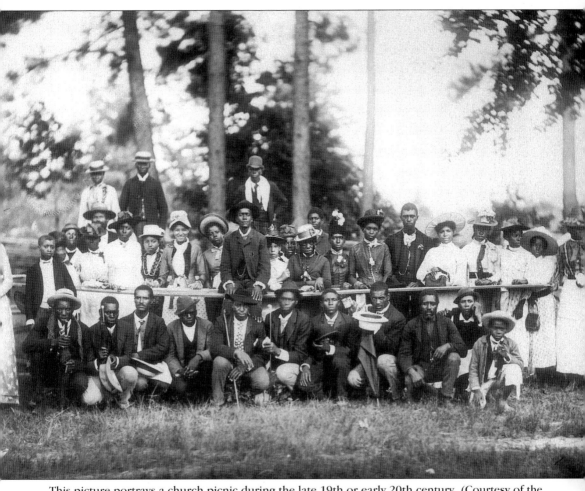

This picture portrays a church picnic during the late 19th or early 20th century. (Courtesy of the Valentine Richmond History Center.)

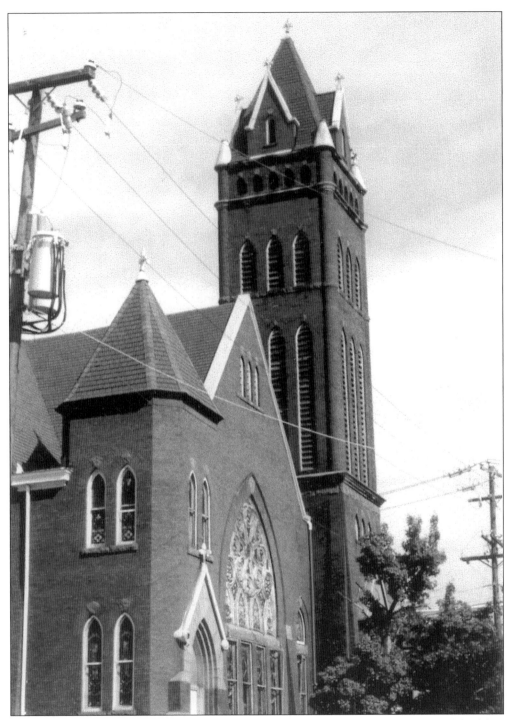

Pictured here is the former Cedar Street Memorial Baptist Church. The present church building is adjacent to this structure. The church began shortly after the Civil War and has one of the largest African-American congregations in Virginia.

Four
EDUCATION

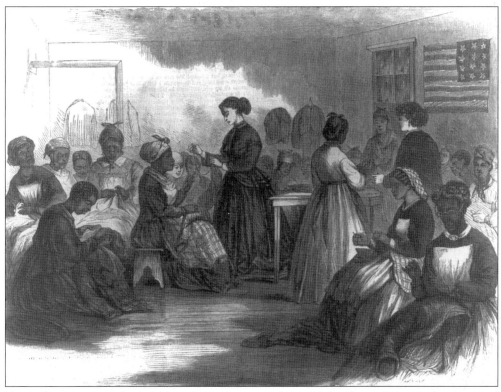

Shown here is a scene from the Freedmen's Union Industrial School in Richmond. The Bureau of Refugees, Freedmen, and Abandoned Lands, commonly referred to as the Freedmen's Bureau, was established within the war department on March 3, 1865. Its primary duties were to oversee labor contracts, maintain schools for the freedmen, coordinate relief efforts for the needy, assist African-American soldiers in collecting pensions and back pay, and oversee the disposition of confiscated or abandoned lands. Ralza Morse Manly, an Army Chaplain, served as the Superintendent of Education in Virginia for the Bureau for the majority of the time that it carried on its educational activities in the state. (Courtesy of Library of Congress.)

Location of School	How Supported	No. of Schools	No. of Teachers	No. of Scholars	Average Attendance	Remarks
						Night School of 100
Chimborazo	N.Y.R. Asso.	1	7	325	251	One Colored Teacher — a man
2d Bap. Church	Do	1	6	224	160	Five Old Lady teachers
Ebenezer Church	Am. Bap. H.M.	1	3	191	125	
Parker High School	Do	1	1	32	27	
1st African Bap. Ch.	Do	1	5	350	275	
3st Methodist Ch.	N.E.F.A. Soc.	1	3	165	140	
Variously Located Chs	By Tuition	12	12	336	278	Two of these schools are good. All Colored Teachers. The rest pu—
Manchester Bap.	Bap. Home Miss	1	1	100	68	A Colored Teacher
Total		19	38	1723	1324	

This monthly report to the Freedmen's Bureau for October 1865 shows some of the earliest Freedmen's Bureau Schools in Richmond. They included day schools, night schools, and Sabbath schools, most of which were primarily financed by northern philanthropic societies and religious organizations. According to this initial report for the Third District, the Chimborazo School and the school at Second Baptist Church were supported by the New York National Freedmen's Relief Association; the schools at Ebenezer Baptist Church, First African Baptist Church, Manchester Baptist Church, and Parker High School were supported by the American Baptist Home Mission Society; and the school located at the Third Street Methodist Church was supported by the New England Freedmen's Aid Society. There were also several other schools that were maintained and run by the freedmen, which often required a small tuition. (Courtesy of the National Archives.)

The Lancaster (Lancasterian) School was built in around 1816. After the Civil War it was used as a school for African-American students and its name was changed to the Valley School. It was located at the corner of Fifteenth and Marshall Streets across from the city jail. Pioneering businesswoman Maggie L. Walker attended this school and later taught here. (Courtesy of the Valentine Richmond History Center.)

MIDDLE CLASS.

EMMA BLUNT,
CORNELIA BROWN,
ELIZABETH V. BROWN,
LAURA J. BURRILL,
LUCY G. BROOKS,
RICHARD A COMBS,
WILLIAM W. FIELDS,
BENJAMIN A. GRAVES,
LUCY HARRIS,
EMMA V. JONES,
JAMES H. JOHNSON,
CARRIE B. KEMP.

MARY M. LINDSEY,
LUCY PELHAM,
VICTORIA POLLARD,
MARTHA E. SAMPSON,
JENNIE SEMMES,
EMMA E. SMITH,
JESSE J. SMITH,
GEORGE STEPHENS,
MARTHA E. WATKINS,
FANNY E. WHITE,
WILLIE A. YANCEY.

JUNIOR CLASS.

J. ANDREW BOWLER,
ELIZA BROWN,
HESTER A. CHEATHAM,
KATE A. DABNEY,
PINKIE DAVIS,
MAGGIE C. DAVIS,
WILLIAM GLASGOW,
MARIA C. HASKINS,
SUSIE M. HILL,
WILLIE T. HILL,
MATTIE M. L. HOPE,
SALLIE C JOHNSON,
LAURA B. JONES,
FANNY C. JONES,
MARGARETTA J. JUDAH,
ALBERT JOHNSON,
ALICE V. LONG,

FANNY MILES,
JAMES E. MERIWEATHER,
MARY E. REESE,
GRACE RICHARDSON,
CAROLINE STANARD,
LELIA SMITH,
MATILDA M. STUTELY,
ROBERTA SMITH,
SUSIE M. TAYLOR,
UPSHUR H. TAYLOR,
JOHN E. TAYLOR,
JOSEPHINE J. TURPIN,
ERNEST MILES,
EMMA J. WALKER,
GEORGE B. WASHINGTON,
DANIEL B. WILLIAMS.

MODEL SCHOOL.

RACHEL BROOKS,
MARY BROWN,
ANTONI CLARK,
BELLE CHRISTIAN,
THOMAS CARTER,
MAGHLVAY COX,
LELIA COLES,
WALKER COLES,
JENNIE EDLETON,
HATTIE FOSTER.

ELIZABETH HASKINS,
OPHELIA HASKINS,
MARTHA HISCOMB,
POLLY HICKS,
LUCY JONES,
JULIA JOHNSON,
MARY JACKSON,
EVELINE KEENE,
SALLY KEENE,
CHARLEY LEIGH,
COLIN VALENTINE.

ALICE LEWIS,
JACOB POWELL,
VICTORIA POWELL,
HATTIE PRICE,
WILLIE RANDOLPH,
ELONORA SHIELD,
JACOB STANNARD,
BLANCHE SCOGGIN,
WILLIE SCOTT,
MILDRED STOKES,

Pictured above is a list of students *c.* 1875 at the Richmond Colored High and Normal School. (Courtesy of the Harry Roberts Collection, Special Collections, Johnson Memorial Library, Virginia State University.)

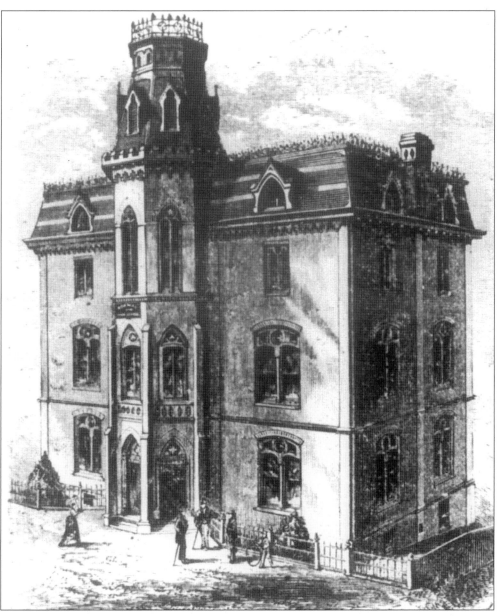

The Richmond Colored Normal School (also known as Richmond Colored High and Normal School) was organized by Ralza Manley in 1867 at the corner of Sixth and Duval Streets. A building was erected for it at the corner of Twelfth and Leigh several years later. In addition to offering the standard high school curriculum, this school also specialized in preparing students to become teachers. The scholarship and reputation of the students and teachers at the school were exemplary and many northerners traveled down to observe the students and teachers at work. (Courtesy of the Harry Roberts Collection, Special Collections, Johnston Memorial Library, Virginia State University.)

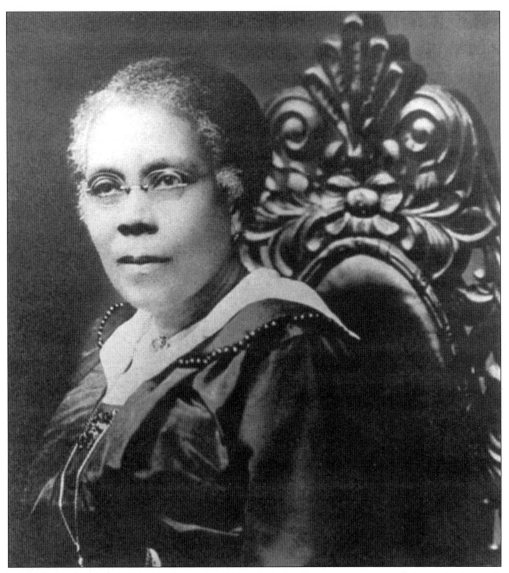

Rosa Dixon Bowser (1855–1931) was a distinguished educator and civic leader in Richmond. Mrs. Bowser was a product of Richmond Colored Normal and went on to become one of the first African-American teachers after the formation of the Richmond Public School System. She was in constant demand as an instructor at summer teaching institutes and was elected president of the Virginia State Teachers Association, serving from 1890 to 1892. A tireless local and national civic leader, Mrs. Bowser's legacy was acknowledged by having the first African-American branch of the Richmond Public Library named in her honor. (Courtesy of the Black History Museum and Cultural Center of Virginia.)

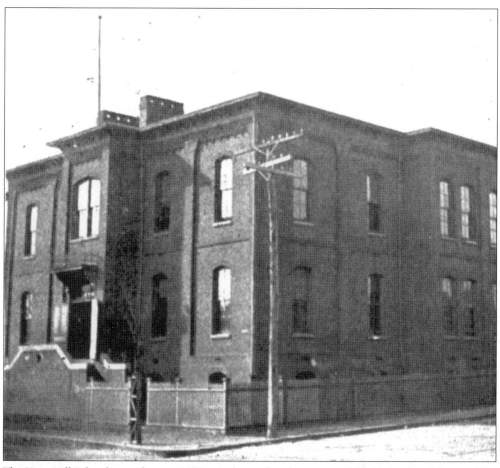

The Navy Hill School, seen here *c.* 1907, was located at the corner of Sixth and Duval Streets. The earlier building was the site of several Freedmen's Bureau schools. (Courtesy of *Souvenir Views*.)

The Moore School was built as a public school for African-American children in 1887. (Photograph by Elvatrice Belsches.)

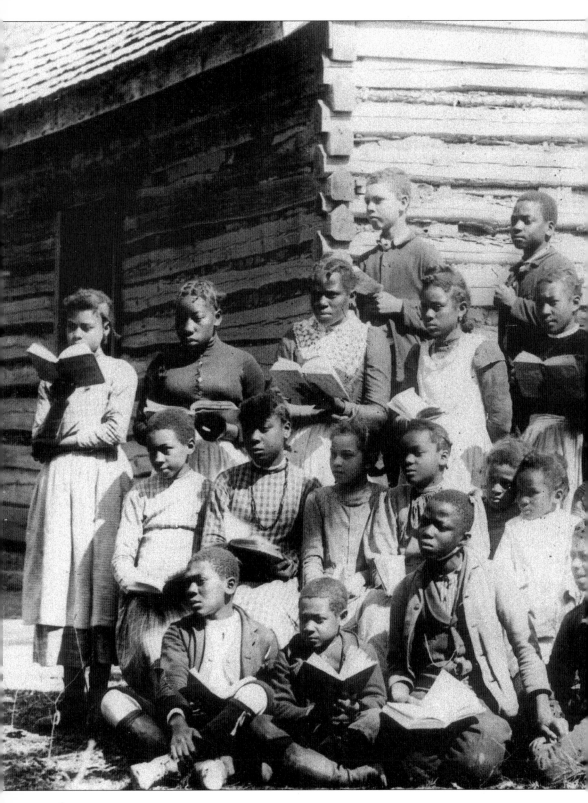

African-American children posed in front of a log school house in the 1890s. (Courtesy of the Cook Collection, Valentine Richmond History Center.)

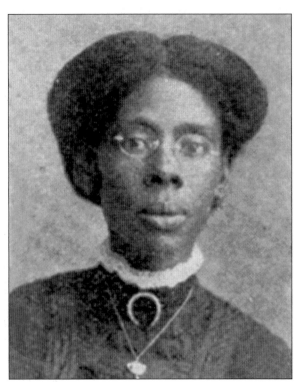

Virginia E. Randolph (1874–1958) was a pioneering educator. A graduate of Richmond Colored Normal, Miss Randolph became the first Jeanes Supervising Industrial Teacher in the country. The Anna T. Jeanes Fund was a trust initiated to foster education for African Americans in the rural South. Her innovative methods of integrating academic subjects with vocational skills would eventually be used throughout the South. Ms. Randolph also founded the Colored Industrial Exchange in Richmond. (Courtesy of Mary E. Alexander.)

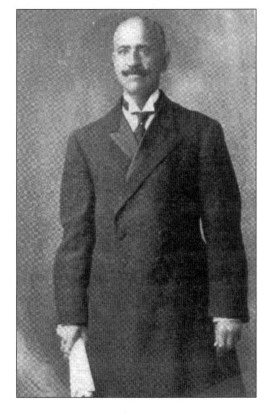

Rev. John Andrew Bowler was an extraordinary educational and religious leader. Reverend Bowler, a graduate of Richmond Colored Normal and the Richmond Theological Institute, began to teach at the elementary school level in Richmond in about 1882. He would later organize the George Mason School and serve in the educational field for over 50 years. In additional to being a beloved educator, he became licensed and ordained to preach around 1900 and became the founding pastor of Mt. Olivet Baptist Church. (Courtesy of the Black History Museum and Cultural Center of Virginia.)

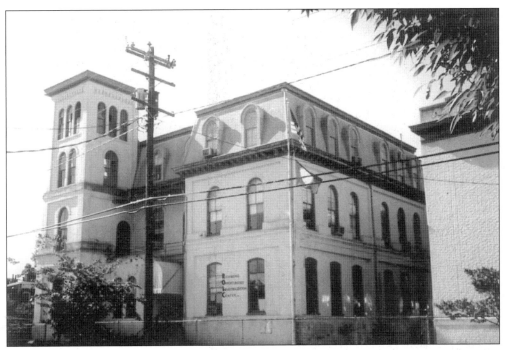

Around 1910, the Richmond Colored High and Normal School was moved to this building on the corner of First and Leigh Streets. This was formerly the white Leigh School. The name was changed to Armstrong High School in honor of the founder of Hampton Institute, Samuel C. Armstrong. (Photograph by Elvatrice Belsches.)

A new Armstrong High School was erected near the corner of Leigh and Price Streets in 1922; it would later become Benjamin Graves Middle School. (Photograph by Elvatrice Belsches.)

The Maggie L. Walker High School was built in 1938 and named in honor of the business pioneer. (Photograph by Elvatrice Belsches.)

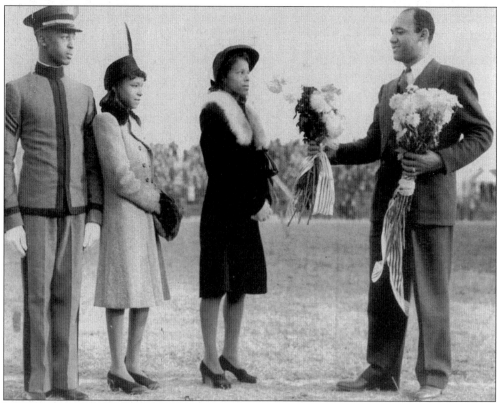

Celebrating the Maggie Walker Homecoming Ceremonies for the year 1941–1942 are (from left to right) Oscar Turner, Edna Henry, Lelia Dickerson (Miss Homecoming), and Principal J.E. Segar. (Courtesy of Lelia Kirksey.)

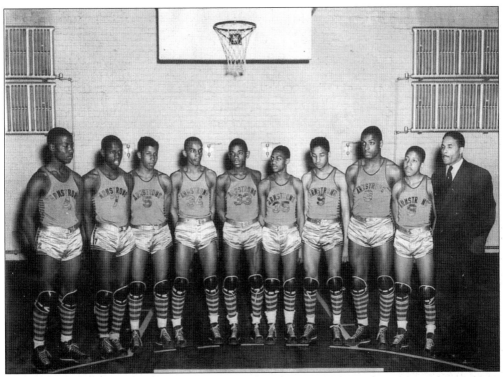

Pictured are the members of the 1941 tournament-winning Armstrong High School basketball team with their coach, the legendary Maxie Robinson. (Courtesy of the Johnston Memorial Library, Virginia State University.)

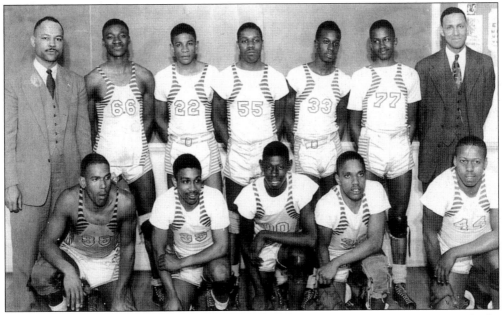

The 1946 tournament-winning Maggie L. Walker basketball team is pictured along with the coaches who led them to victory.

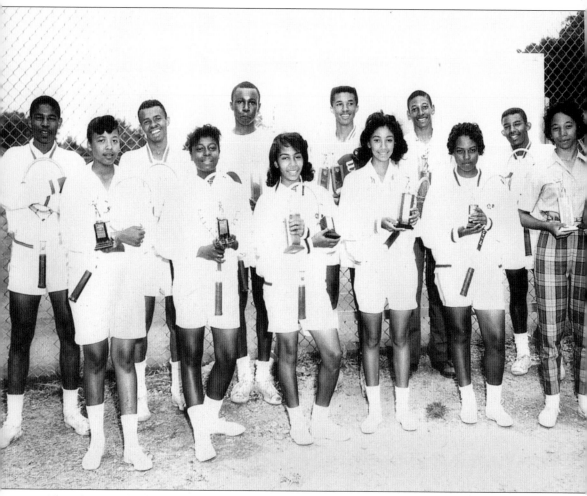

This photograph of the 1960 State Championship tennis team of Maggie L Walker High School incudes native Richmonder Arthur Ashe (fourth from the left on the second row). Ashe would go on in 1968 to become the first African-American man to win the U.S. Open and in 1975, the first African-American man to win at Wimbledon.

Five
VIRGINIA UNION
UNIVERSITY

Shortly after the Civil War, the American Baptist Home Mission Society started the Richmond Theological Institute for the freedmen. Rev. Nathaniel Colver was sent to to find a permanent home for the school. Reportedly he happened upon Mrs. Mary Lumpkin, the African-American widow of noted slave trader and jailer Robert Lumpkin. Lumpkin's slave jail, located between Franklin and Broad near Fifteenth Street, was known as the Devil's Half Acre by slaves. Mrs. Lumpkin leased the old jail to Colver for three years, and it became the first classroom for what would become Virginia Union University. Near the turn of the century the American Baptist Home Mission Society decided to move the Wayland Seminary and College from Washington, D.C. and merge it with the Richmond Theological Seminary to form Virginia Union University. (Courtesy of L. Douglas Wilder Library, Virginia Union University.)

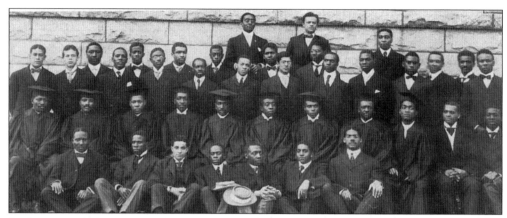

Students at Virginia Union University are the subject of this 1906 photograph. (Courtesy of *An Era of Progress and Promise*.)

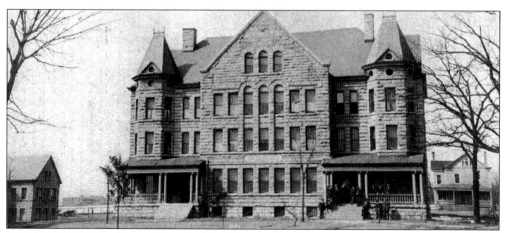

Kingsley Hall, a dormitory of Virginia Union University, is pictured *c.* 1906. It was named in honor of donor Chester Kingsley of Boston, Massachusetts. (Courtesy of *An Era of Progress and Promise*.)

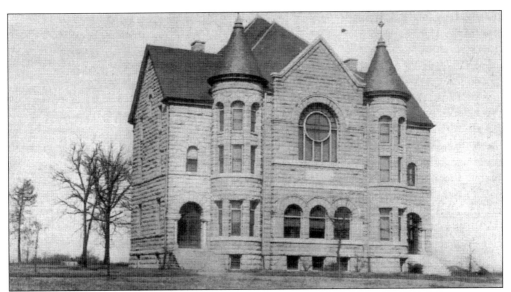

Coburn Hall Chapel at Virginia Union University was named in honor of donor Governor Coburn of Maine. It is shown here *c.* 1906. (Courtesy of *An Era of Progress and Promise.*)

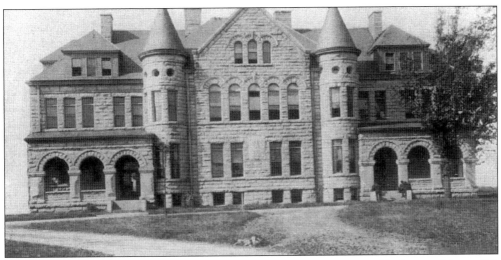

Pickford Hall, shown here *c.* 1906 at Virginia Union University, was named in honor of donor C.J. Pickford of Massachusetts. (Courtesy of *An Era of Progress and Promise.*)

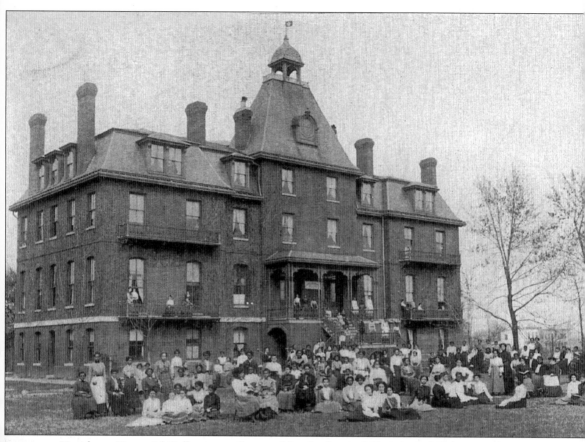

Hartshorn Memorial College was chartered by the State of Virginia in 1884. It was located on eight and one-half acres that were adjacent to Virginia Union University. It was founded by Joseph Hartshorn in honor of his wife to provide a Christian-based education to women. It would later merge with Virginia Union in 1932. (Courtesy of *An Era of Progress and Promise*.)

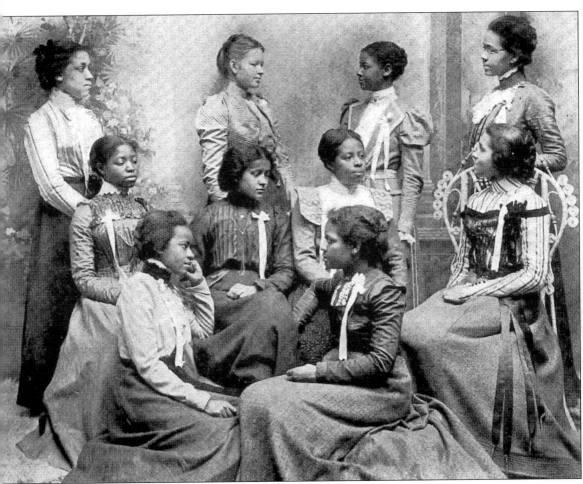

Pictured here is the 1901 graduating class of Hartshorn Memorial College. (Courtesy of the *Hartshorn Memorial College Annual Catalog, 1901–1902.*)

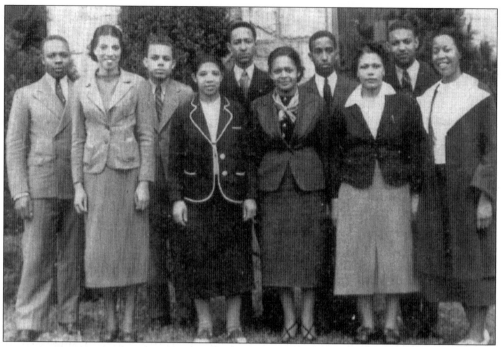

The 1932 Virginia Union University Student Senate is pictured in this photograph. (Courtesy of Martha Thompson.)

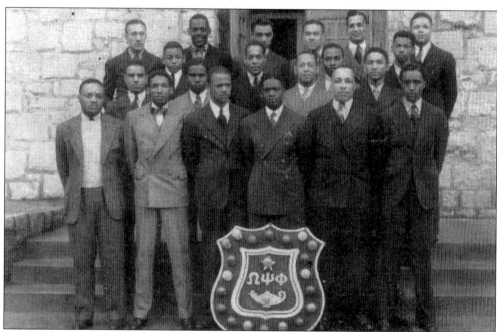

Shown here are the 1932 members of the Omega Psi Phi Fraternity at Virginia Union University. (Courtesy of Martha Thompson.)

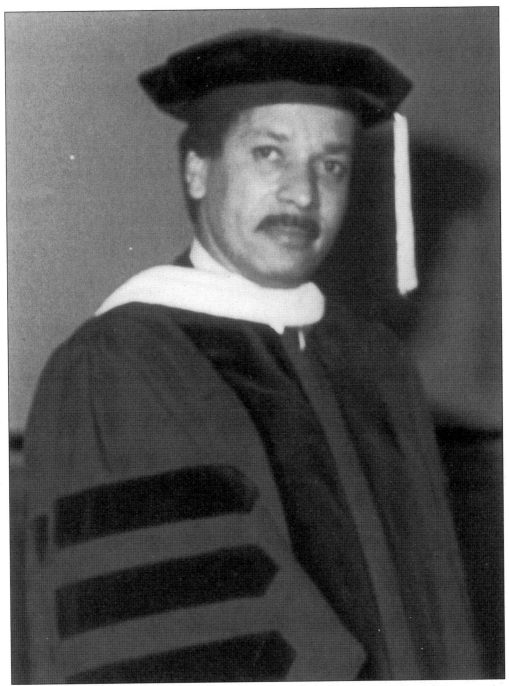

In 1978, Richmond native and Virginia Union University alumnus Max Robinson became the first African-American newsman to regularly anchor a national network news program. He was hired by ABC Television as one of the anchors for *World News Tonight*. (Courtesy of Senator Benjamin Lambert III.)

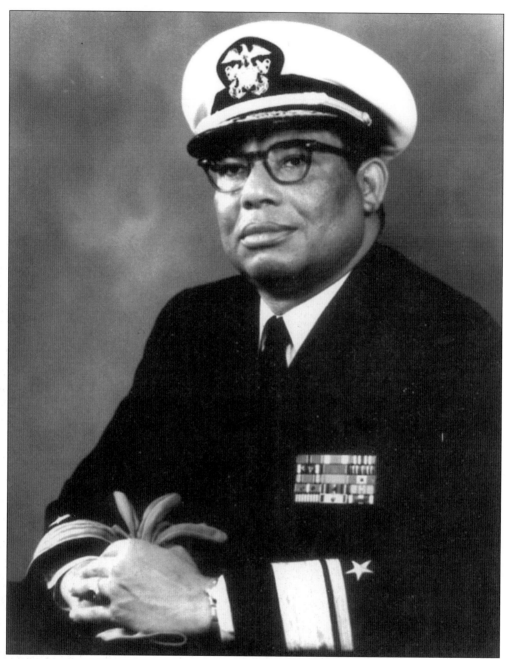

Virginia Union University alumnus and Richmond native Samuel L. Gravely Jr. achieved several firsts during his career in the Navy. His pioneering achievements include being the first African American to command a U.S. warship in modern times and the first African American to command a U.S. fleet. He also became the first African American to earn the rank of Admiral. (Courtesy of the United States Navy-Navy Historical Center.)

Six
MEDICINE

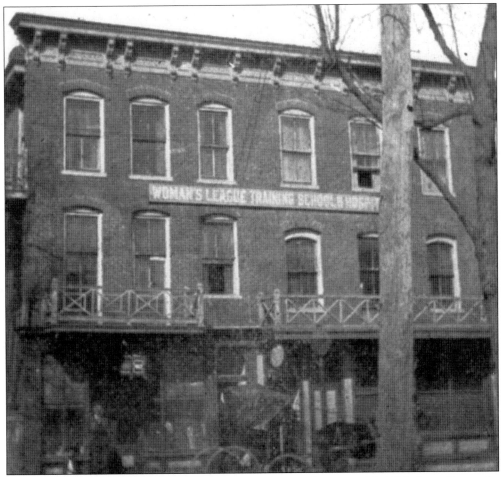

The Woman's League Training School and Hospital opened on June 26, 1900. According to the June 30, 1900 edition of *The Richmond Planet*, this hospital, which was located at 412–14 North Third Street, had an operating room within the hospital department, a cooking department, and an industrial department. (Courtesy of *Souvenir Views.*)

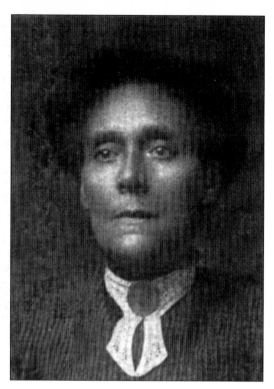

Dr. Sara G. Jones became the first woman and African American to pass the medical boards in Virginia. She did so in 1893 with a score of 90. Dr. Jones was the daughter of George Boyd, a noted Richmond contractor. Upon graduating from Richmond Colored High and Normal School, Sarah Boyd began to teach at Baker School. She would later meet and marry fellow educator Miles B. Jones (pictured below). Both decided enter the medical profession with Dr. Sarah Jones graduating from Howard University in 1893 and her husband from the same institution in 1901. The Joneses would go on to co-found along with others the Richmond Hospital and Training School for Nurses in 1902.

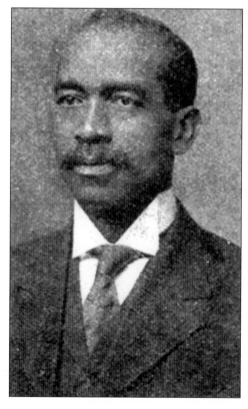

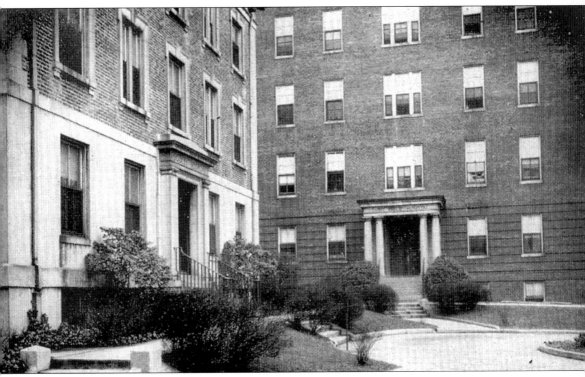

Pictured above *c.* 1941 are the former Dooley (left) and St. Philip Hospitals (right). During the era of segregation, African-American children were accomodated at the Dooley Hospital and African-American adults at St. Philip. Both hospitals were associated with the Medical College of Virginia. (Courtesy of the Black History Museum and Cultural Center of Virginia.)

Dr. M. Janie Jones, the sister of Dr. Sarah Jones, is pictured in 1952. She began practicing medicine in 1912. Remembered and beloved by many, she made house calls and practiced medicine into her 90s. (Courtesy of *Our World* magazine.)

RICHMOND'S GREATEST NEED--

The Richmond Community Hospital Campaign is an appeal to the conscience and humanity of the citizens of Richmond regardless of race.

Never before in the history of the city has a civic enterprise been endorsed with such a unanimity of sentiment as has this hospital project. Read the faces of the people who are serving this cause and with one accord they are broadcasting this message to every person in Richmond who believes in the future of Richmond.

"Build this hospital now." Richmond owes proper hospitalization to the colored citizens. They do not have it now and this s said not in criticism of the hospitals which are now serving colored people but is based upon facts which are manifest. 32 physicians treating 70% of the colored population of Richmond are denied the opportunity to practise their profession in any hospital in Richmond. This is a peril to the health of the community which should not be regarded with indifference. In view of its past reputation, Richmond will not fail to correct this condition. Justice, self-respect and loyalty to the best interests of Richmond demand action now.

Let every citizen make a sacrifice and resolve in his heart to give liberally of his time, talent and means to the end that disease and suffering may be successfully combated and health and happiness placed in the reach of even the most humble of our fellowmen. This Campaign is a test of the sincerity of your Christian profession.

FACTS CONCERNING THE HOSPITAL CAMPAIGN

The Campaign is launched for the purpose of raising $200,000 to build a modern hospital for colored people.

The lot upon which the hospital will be bu lt adjoins the campus of the Virginia Union University and was purchased by the Hospital Association at a cost of $12,000.00. The lot is paid for.

The building now owned by the Association 4C6 East Baker Street, is also clear of debt and will be sold and the money used in the new hospital project.

The plans for the new building have been drawn and accepted and negotiations are now in progress to let the building contract.

The city is divided into ten districts and each district is assessed a quota to raise. You live in one of these districts.

The Business and Professional Divisions composed of the Doctors, Nurses, Dentists, Pharmacists and Business men have already given assurance that their quotas which aggregate $60,000.00 will be subscribed.

Each church, fraternal organization, club and society will be asked to contribute to the fund, but these gifts are independent of your personal gift.

The gifts are paid in cash or as follows: one-fifth cash and one-fifth each year thereafter for four years.

The Campaign begins June 10, 1927 and closes June 25, 1927.

Every person in Richmond is asked to give at least $50.00 to this cause and to use his influence in its behalf.

Listen to the solicitor who calls on you. These persons are working unselfishly. They deserve your patient attention and your genuine cooperation.

This brochure was circulated in 1927 to solicit funds to build a new African-American hospital, which was to be called the Richmond Community Hospital.

This is a 1950s photograph of the Richmond members of Chi Delta Mu Medical Society. Starting at the front head of the table and proceeding counter-clockwise, they are as follows: Dr. Gregory Shaed; (row closest to foreground) Dr. William Williams, Dr. Nathaniel Dillard, Dr. M. M. Gordon, Dr. Leslie Winston, Dr. Roosevelt Harrington, Dr. Edwin Ragland, Dr. Francis Foster, Dr.

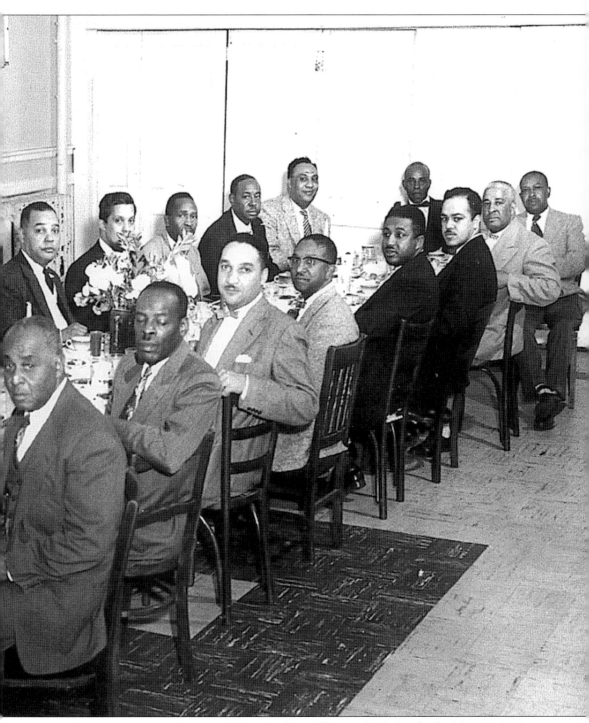

Daniel Davis, Dr. W.A. Green, and Dr. Stanley Williams; (back head of table, continuing counterclockwise) Dr. Ivan Fraser, Dr. James Brown, Dr. Felix Brown, Dr. Everett C. White, Dr. Charles Johnson, Dr. Leonard Edloe Sr., Dr. Barrington Bowser, Dr. William C. Calloway, and Dr. Davidson. (Courtesy of Alice Calloway.)

Richmond Community Hospital was built on a lot adjacent to Virginia Union University on Overbrook Road in 1932. This building is now a part of the campus. Richmond Community is now a 104-bed facility located on Twenty-eighth Street. (Photograph by Elvatrice Belsches.)

Francis M. Foster Sr. DDS is the authority on the history of African Americans in Richmond. In addition to being an extraordinary historian, Dr. Foster practiced dentistry for over 40 years before retiring from private practice. He has for a number of years served as a clinical professor in the School of Dentistry at the Medical College of Virginia. Dr. Foster has served on numerous historical and literary commissions and has won numerous awards for his dedication to the community and the fields of education and dentistry. (Courtesy of the Black History Museum and Cultural Center of Virginia.)

Dr. John Howlette O.D., D.O.S. is a pioneering optometrist in Richmond. He has practiced for over 50 years within the historic Jackson Ward district. Dr. Howlette, one of the first African-American optometrists in the state, co-founded along with Dr. C. Clayton Powell of Atlanta, the National Optometric Association in 1968. Through this organization and through the American Optometric Association, Dr. Howlette has successfully recruited other minorities into the profession. Dr. Howlette serves on numerous boards and has won many awards for his service to the community and his profession. In October of 2001 Dr. Howlette became the first Virginian inducted into the National Optometric Hall of Fame in Ohio. (Photograph by Elvatrice Belsches.)

Seven

POLITICS

```
┌─────────────────────────────────────────────────────────────┐
│                                                               │
│              African-Americans Who Served on the             │
│           Richmond City Council During the 19th Century      │
│                                                               │
│                                                               │
│   John Adams                          Benjamin Jackson        │
│                                                               │
│   Edinboro Archer                     Robert W. Johnson       │
│                                                               │
│   Andrew J. Brown                     Robert E. Jones         │
│                                                               │
│   Edward R. Carter                    James A. Lewis          │
│                                                               │
│   Isaac W. Carter                     John Mitchell Jr.       │
│                                                               │
│   Josiah Crump                        Henry J. Moore          │
│                                                               │
│   Morton Deane                        Edwin Archer Randolph   │
│                                                               │
│   Joseph E. Farrar                    Jordan A. Robinson      │
│                                                               │
│   Richard G Forrester                 Sandy W. Robinson       │
│                                                               │
│   Jackson Foster                      William B. Smith        │
│                                                               │
│   Joshua R. Griffin                   Alfred Thornton         │
│                                                               │
│   James H. Hayes                      Nelson P. Vandervall    │
│                                                               │
│                                       Reyall White            │
│                                                               │
└─────────────────────────────────────────────────────────────┘
```

This list of African Americans who served on the Richmond City Council during Reconstruction was taken from the publication *Negro Office-Holders in Virginia, 1865–1895* by Dr. Luther Porter Jackson. The City Council of Richmond was comprised of the Board of Aldermen and the Common Council. During the Reconstruction era, 25 African Americans served on the city council. The 1890s, however, ushered in an era of disfranchisement and by 1900 there were no African-American members on city council. An African American would not win an election to city council again until 1948.

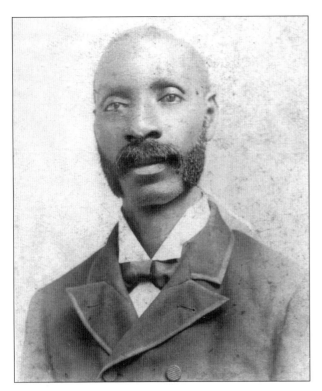

Morton Deane, a Reconstruction-era city council member, was a native of Buckingham County, Virginia, and was employed by the Tredegar Iron Works. (Courtesy of Martha Thompson.)

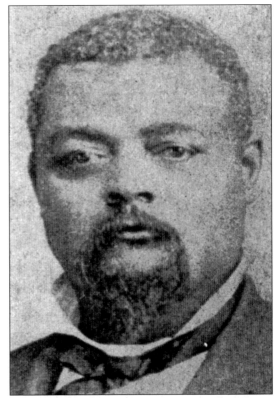

Josiah Crump was a highly respected member of the council during Reconstruction. He served as a member of the Board of Alderman from Jackson Ward. (Courtesy of *Negro Office-Holders in Virginia, 1865-1895*.)

Richard G. Forrester served as a
Reconstruction -era council member.
(Courtesy of *Negro Office-Holders in
Virginia, 1865-1895*.)

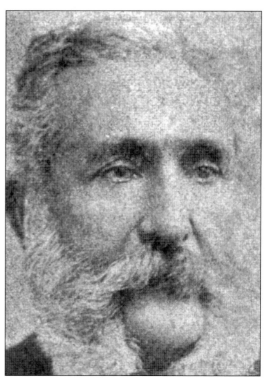

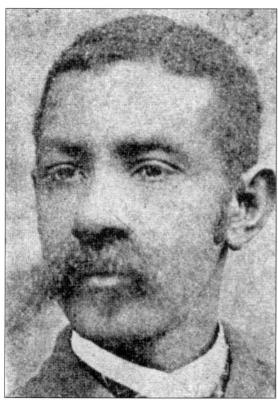

John H. Adams was not only a
Reconstruction-era council member but
also a successful contractor. (Courtesy
of *Negro Office-Holders in Virginia,
1865-1895*.)

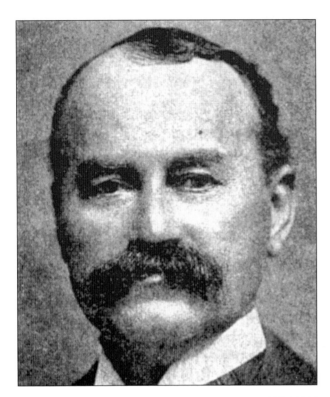

Henry J. Moore was a successful contractor and Reconstruction-era city council member. (Courtesy of *Negro Office-Holders in Virginia, 1865-1895.*)

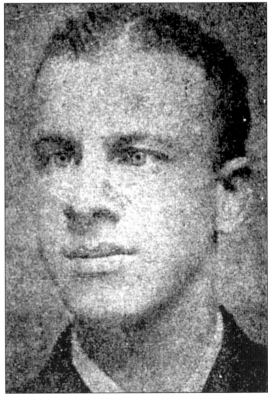

Edward R. Carter was a well-respected Reconstruction-era council member. He was also one of the founders of *The Richmond Planet* newspaper. (Courtesy of *Negro Office-Holders in Virginia, 1865-1895.*)

John Mitchell Jr. was a Reconstruction-era council member who served for nearly 50 years as the editor and proprietor of *The Richmond Planet.* He also founded the Mechanics Savings Bank. Mitchell would go on to run for governor in 1921.

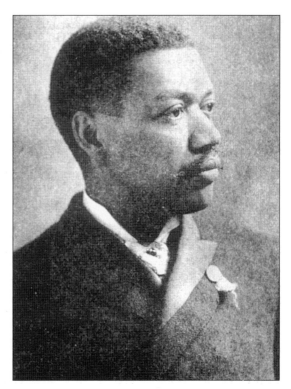

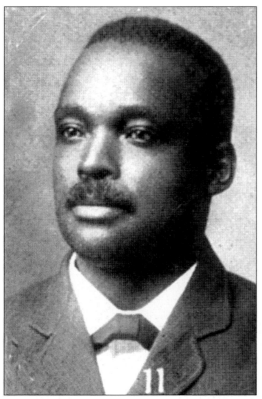

James H. Hayes was a gifted lawyer and teacher who served on city council during Reconstruction. (Courtesy of the National Park Service, Maggie L Walker National Historic Site.)

Noted civil rights lawyer Oliver W. Hill was elected to the city council in 1948, making him the first African American to win election to city council in the 20th century. (Courtesy of Atty. Oliver W. Hill Sr.)

On the left is Reconstruction-era City Councilman Edward R. Carter, shown here at the age of 95, and retired barber John Powell, at age 87. This photograph was taken in 1952. Carter was the only Reconstruction-era councilman who lived to see Oliver Hill win election to the city council in 1948. (Courtesy of *Our World* magazine.)

Surgeon Dr. William Ferguson Reid became the first African American elected to the Virginia Legislature in the 20th century. Elected in 1967, he is shown here with his son Fergie. Dr. Ferguson was also one of the founders, along with Dr. William Thornton Sr., John Mitchell Brooks, and others, of the Richmond Crusade for Voters in 1956. (Courtesy of Dr. William Ferguson Reid.)

Attorney Henry L. Marsh III made history in 1977 when he became the first African-American mayor of Richmond. Also a noted civil rights lawyer, Senator Marsh has been a member of the Virginia State Senate since 1992. (Courtesy of the Virginia General Assembly.)

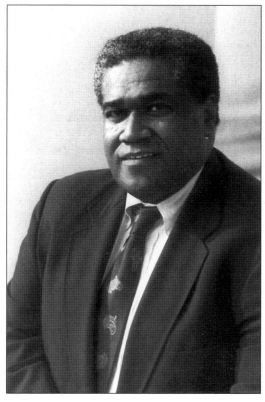

Sen. Benjamin J. Lambert III has been a member of the Virginia State Senate since 1986, after having served in the House of Delegates from 1978 to 1985. In addition to serving on several influential committees, Dr. Lambert serves on the Board of Directors for the Consolidated Bank & Trust Co., Dominion Resources, USA Education Inc., and a host of others. As an optometrist he has been honored by both the Virginia Optometric Association and the National Optometric Association. (Courtesy of Sen. Benjamin J. Lambert III.)

In 1989 L. Douglas Wilder became the first African-American governor in the United States. He is shown here in January of 1990 taking the oath of office, flanked by daughters Lynn Wilder (left) and Loren Wilder (right). Under his tenure as the Governor of Virginia, the state was ranked

by *Financial World* as the best fiscally managed state for two consecutive years. (Courtesy of the L. Douglas Wilder Library, Virginia Union University.)

In 1992 Robert C. "Bobby" Scott became only the second African American from Virginia to be elected to the United States House of Representatives from Virginia. Representative Scott, whose district includes parts of Richmond, has been a dedicated public servant for many years, having served in both the Virginia House of Delegates and the Virginia State Senate prior to being elected to Congress. (Courtesy of Senator Benjamin Lambert III.)

Eight
CIVIL RIGHTS

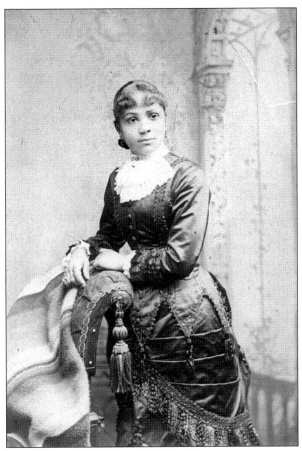

Pioneering entrepreneur Maggie L. Walker, pictured here as a teenager in the 1880s, led a school boycott to protest the inequalities of the graduation ceremonies for students of the Richmond Colored High and Normal School. (Courtesy of the National Park Service, Maggie L. Walker National Historic Site.)

PROCEEDINGS

OF

THE NEGRO PROTECTIVE

Association,

OF VIRGINIA,

Held Tuesday, May 18th, 1897.

IN THE

True Reformers' Hall,

Richmond, Va.

———

Richmond, Va., May 4th, 1897.

Dear Sir: Believing that it is of the greatest importance that the Negroes of Virginia, like the Negroes of the other Southern States, should organize, and become acquainted with each other, before holding of the State Convention this summer, we take this means of inviting you, and any friend or friends you may also invite, to attend a conference of colored men to be held in Richmond, May 18th, 1897, at noon, True Reformer's Hall.

Matters of the greatest importance to the Negroes as a race will be considered; and it is hoped that you will be present even if you will have to make some sacrifice to do so.

One reason why the Negro is so badly treated, is because he has no organization. Organization will beget for us that consideration which nothing else can.

If you can't be present, send a letter expressing your views upon the subject.

Very respectfully,

A. W. Harris, Chairman,
 Member State Committee.
 James H. Hayes, Esq., Sec'y.
R. H. Smith, Delg. Rep. Nat. Con.
M. N. Lewis, Esq., Ed. Norfolk Recorder.
Hon. John H. Smyth, Ex-Minister to Liberia.
Dr. R. E. Jones.
Jas. I. Mitchell, Mem. State Com.
W. G. Singleton, Mem. State Com.
R. B. Baptist, Mecklenburg, Va.
J. H. Harrison, Alexandria, Va.
Robt. Cox, Ch. City Rep. Com., Lynchburg, Va.
C. C. Steward, Esq., Editor Ship, Goodson, Va.

Pursuant to the above call, on Tuesday, May 18th, 1897, at noon,

The Negro Protective Association was an early civil rights organization.

Attorney Martin A. Martin, remembered as a brilliant civil rights lawyer, is shown here in 1943 being sworn in as the first African-American member of the Trial Bureau of the Department of Justice. Martin would later join Oliver Hill in the Richmond law firm of Hill, Martin & Robinson. Pictured from left to right are Attorney Oliver Hill; Frank Coleman, special assistant to Attorney General Biddle; and Mrs. Nellie G. Plumley, who is administering the oath. (Courtesy of Library of Congress.)

Pictured here, from left to right, are an unidentified man, noted Richmond civil rights lawyer Oliver Hill, education scholar J. Rupert Picott, education scholar and expert witness Dr. Thomas Henderson of Virginia Union University, and brilliant Richmond civil rights lawyer Spottswood W. Robinson III. Law partners Hill and Robinson along with their associates filed many cases in an attempt to overturn the unjust separate-but-equal doctrine. Their case, *Dorothy Davis et al. v. County School Board of Prince Edward County, Virginia* would become one of the five cases heard before the U.S. Supreme Court under *Brown v. Board of Education*. Born in Richmond in 1907, Atty. Oliver W. Hill Sr. graduated second from the Howard University Law School in 1933 behind his good friend Thurgood Marshall. He would go on with his law partners to successfully

argue several landmark cases. He has received many awards and appointments for his lifelong commitment to civil rights. In 1999 he was awarded the Presidential Medal of Freedom by Pres. Bill Clinton. Atty. Spottswood W. Robinson III (1916–1998) graduated from the Howard University Law School with reportedly the highest scholastic average ever achieved at the school. Known as a brilliant and meticulous lawyer, Robinson would go on to become dean of the Howard University Law School. In 1964 he became the first African American appointed to the U.S. District Court for the District of Columbia, and in 1966 Pres. Lyndon Johnson elevated Judge Robinson to the U.S. Court of Appeals for the District of Columbia Circuit.

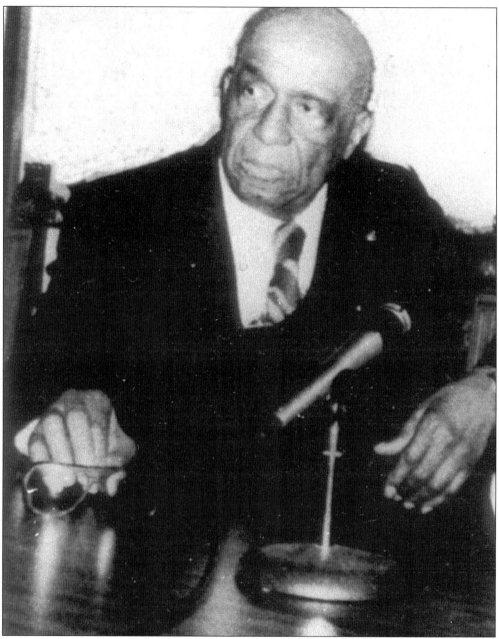

Atty. Samuel Tucker (1913–1990) received his undergraduate degree from Howard University in 1933. From a young age Tucker read law books and passed the Virginia Bar without ever attending law school. Remembered as a brilliant litigator, Tucker later joined forces with Oliver Hill, Henry Marsh, and others to successfully overturn unfair practices in several landmark cases.

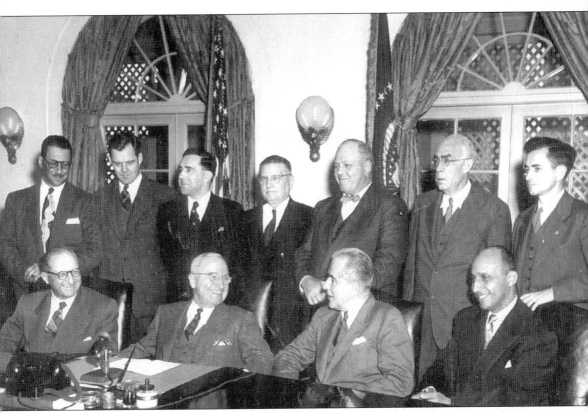

Pictured here in 1951 are Pres. Harry S Truman and the President's Committee on Government Contract Compliance. Atty. Oliver Hill Sr. is seated on the first row on the far right.

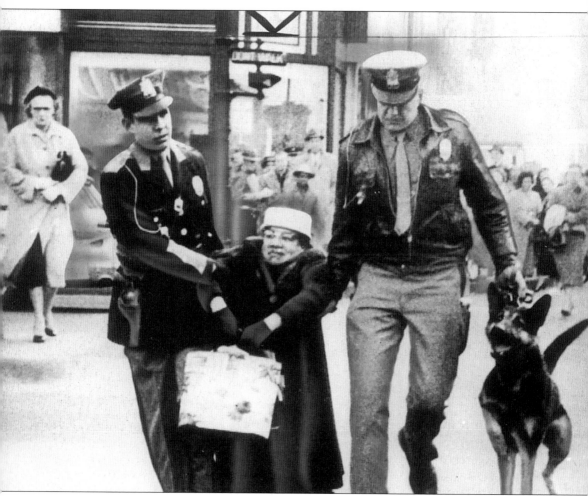

Mrs. Ruth Tinsley is pictured here in 1960 being dragged from a Richmond, Virginia department store by two policemen, after she refused to move on during picketing. This photo, which was later featured in *Life* magazine, was taken by African-American photographer and Richmonder Scott Henderson. Mrs. Tinsley was the wife of Dr. Jesse Tinsley, who served as president of the Virginia State Conference of the NAACP for many years. (Courtesy of Library of Congress.)

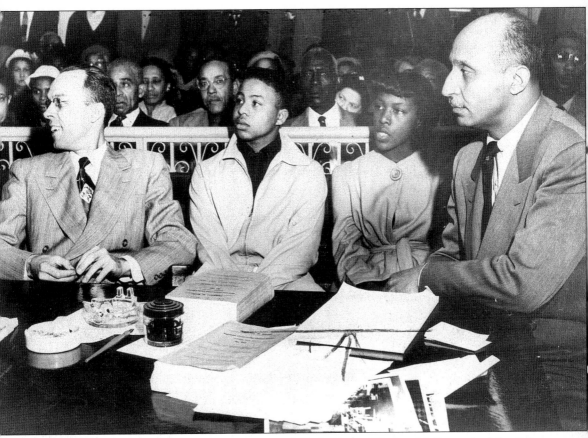

Pictured from left to right are Atty. Spottswood W. Robinson III, Special Counsel of the S.E. Region of the NAACP; students George Leakes and Elaine Bowen; and Attorney Oliver Hill, Chief Counsel of the Virginia State Conference of the NAACP. They listen as witnesses and others are questioned in regard to the West Point, Virginia school cases of 1953. (Photograph by Scott Henderson; courtesy of Library of Congress.)

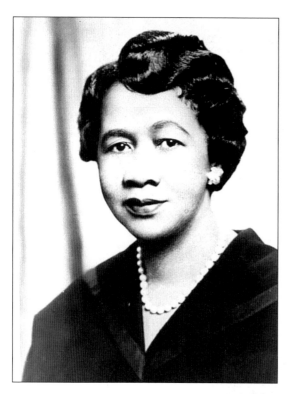

Born in Richmond in 1912, Dorothy Height has dedicated her life to public service, championing equal rights for women and minorities and strengthening African-American families. Chosen by Mary McLeod Bethune to head the National Council of Negro Women, Ms. Height would go on to successfully head this organization for several decades. She was also an integral member of the leadership of the Civil Rights Movement and worked closely with Dr. Martin Luther King and other noted activists. She has been the recipient of many awards and honors, including the Presidential Medal of Freedom. (Courtesy of Library of Congress.)

Born in Richmond in 1926, Atty. Robert M. Alexander has won several landmark civil rights cases. As a trial attorney and co-counsel with Allison Brown, he prevailed in the landmark United States Supreme Court joint decision that resulted in the integration of private day schools across America. In June 2001 Attorney Alexander was awarded the Oliver W. Hill and Samuel W. Tucker Lifetime Achievement Award by the Old Dominion Bar Association for his dedication to civil rights. (Courtesy of Robert M. Alexander.)

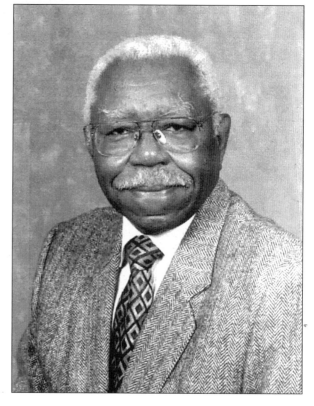

Nine

ENTERTAINMENT
PIONEERS

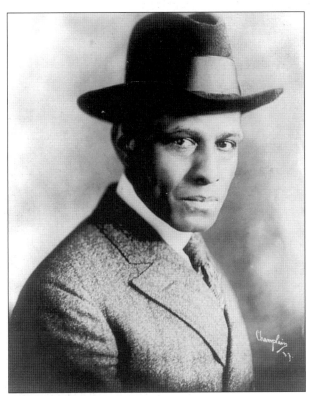

Charles Gilpin was born in Richmond in about 1878. He left school at an early age to become an apprentice at *The Richmond Planet*. He would later travel to New York and Chicago and hone his skills in the theatre. Gilpin is best remembered for his award-winning performance of the leading role in Eugene O'Neill's play *The Emperor Jones*. Considered to be one of the first African Americans to play a leading role in a white production, Gilpin received national acclaim.

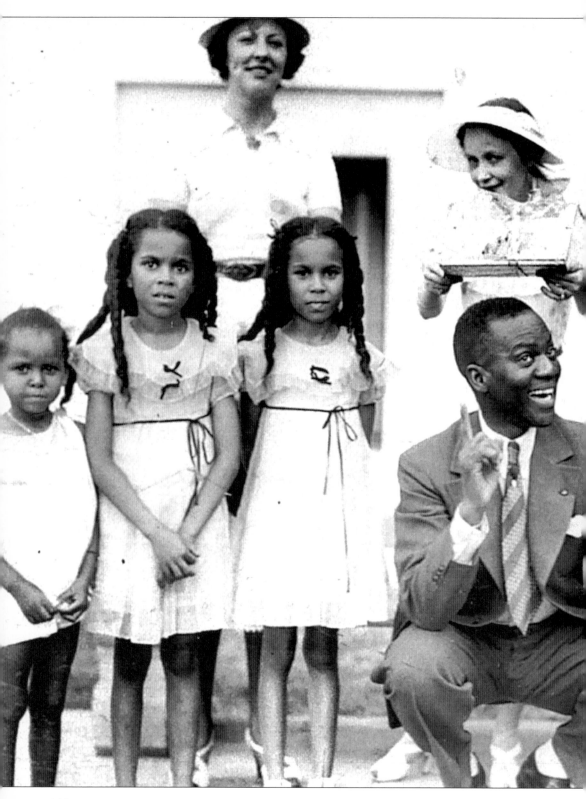

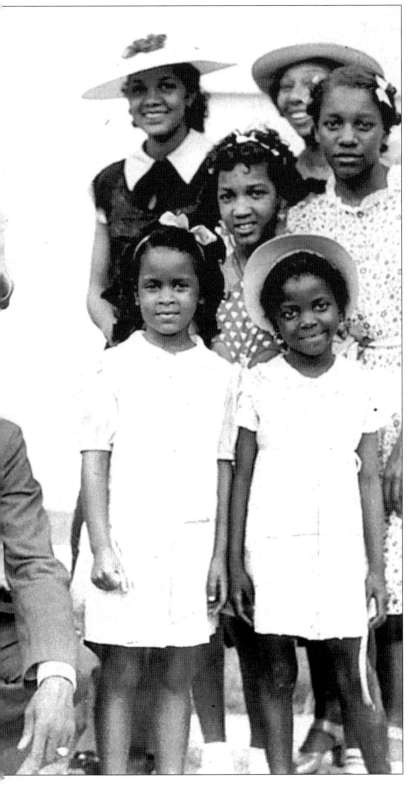

Born Luther Robinson in Richmond in about 1878, Bill "Bojangles" Robinson would go on to achieve critical acclaim as a dancer on Broadway and in Hollywood. Robinson starred in films with Shirley Temple and many others. He was also known for his philanthropy and is honored with a statue and a theatre in his hometown.

Richmond native and conductor Isaiah Jackson has drawn international acclaim as a music director and conductor. As a guest conductor he has led several well-known orchestras, including the Boston Pops, the Los Angeles Philharmonic, and several in Europe. He made history when he became the first American to be appointed music director of the Royal Ballet. He was most recently appointed music director of the Pro Arte Symphony of Boston. (Courtesy of Pro Arte Symphony.)

Ten

LANDMARKS

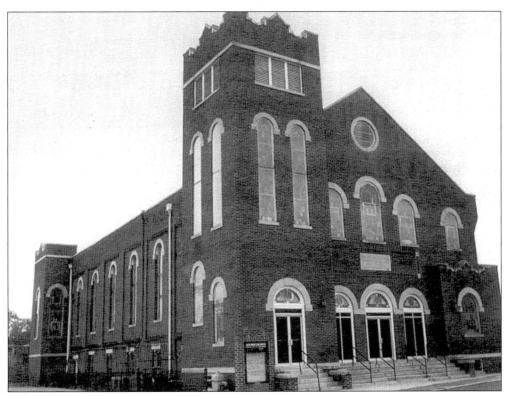

The Sixth Mount Zion Baptist church, located at 14 West Duval Street, is listed on both the Virginia Register of Historic Places and the National Register of Historic Places. (Courtesy of Sixth Mount Zion Baptist Church.)

This statue of native son, humanitarian, and tennis great Arthur Ashe is located at the intersection of Monument and Roseneath Avenues. (Photograph by Theodore S. Holmes.)

The Virginia Randolph Cottage Museum houses the memorabilia associated with pioneering educator Virginia Randolph. In 1976 this building was named a National Historic Landmark. It is located at 2200 Mountain Road. (Photograph by Elvatrice Belsches.)

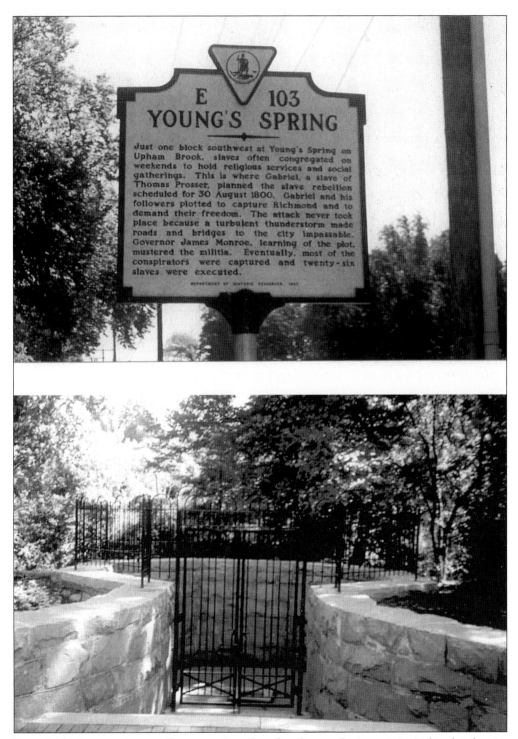

Young's Spring was, reportedly, a meeting place for slave gatherings. It is said to be the site where Gabriel, a slave of Thomas Prosser, gathered with others to mount a rebellion in 1800. It is located off of Lakeside Avenue. (Photograph by Elvatrice Belsches.)

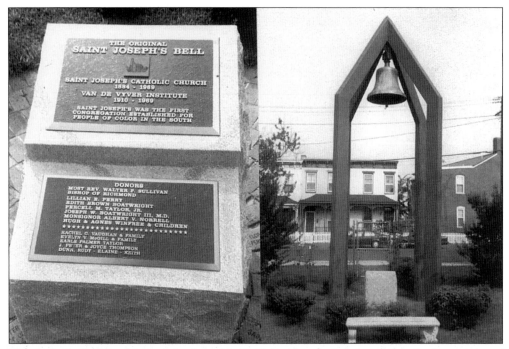

This is the bell of the former Saint Joseph's Catholic Church. It is located at the former site of the church in the 700 block of North Second Street. Saint Joseph's Catholic Church was one of the first catholic churches founded for African-Americans in the South. (Photograph by Elvatrice Belsches.)

Constructed in 1876, this building was formerly the home of the First African Baptist Church. Located at the corner of College and Broad Streets, it is now a part of the campus of the Medical College of Virginia. (Photograph by Elvatrice Belsches.)

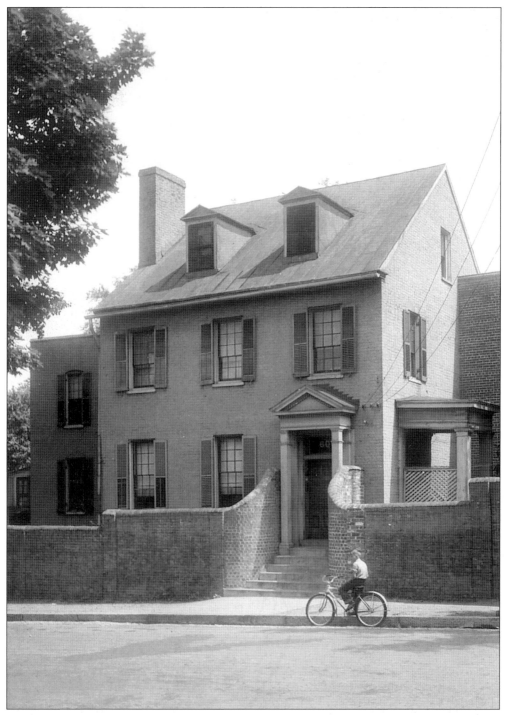

Pictured here in the 1930s, the Samuel Parsons House is located at 601 Spring Street. It is strongly believed to have been a stop on the Underground Railroad. Built in around 1818, it was formerly the home of Quaker abolitionist Samuel Pleasants Parsons. (Courtesy of Library of Congress.)

Known as "Quality Row," the 100 block of East Leigh Street in Jackson Ward was home to many influential African-American entrepreneurs and leaders. Pioneering businesswoman Maggie L.

Walker lived at 110 1/2 East Leigh Street. (Courtesy of Library of Congress.)

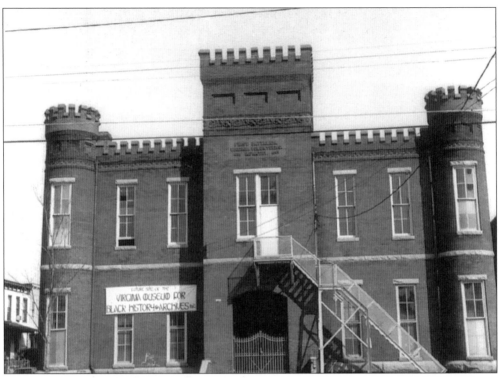

The Armory of the First Battalion, Sixth Virginia Volunteers was built in 1895 for the African-American soldiers who were mustered into service during the Spanish-American War. It later served as the Monroe School during the early 1900s. It is located on West Leigh Street. (Photograph by Theodore S. Holmes.)

The home of free African Americans before emancipation, the Tucker Cottage dates back to the late 1700s. It has been moved to a temporary location on North Second Street. (Photograph by Theodore S. Holmes.)

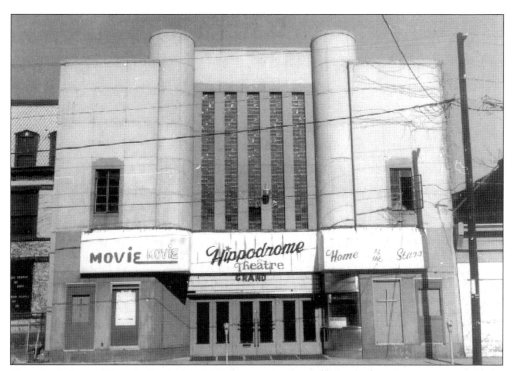

The Hippodrome Theater, located at 528
North Second Street, was home to
many performances and movies
by African-American celebrities.
(Courtesy of the Virginia Department
of Historic Resources.)

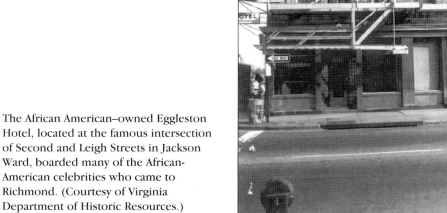

The African American–owned Eggleston
Hotel, located at the famous intersection
of Second and Leigh Streets in Jackson
Ward, boarded many of the African-
American celebrities who came to
Richmond. (Courtesy of Virginia
Department of Historic Resources.)

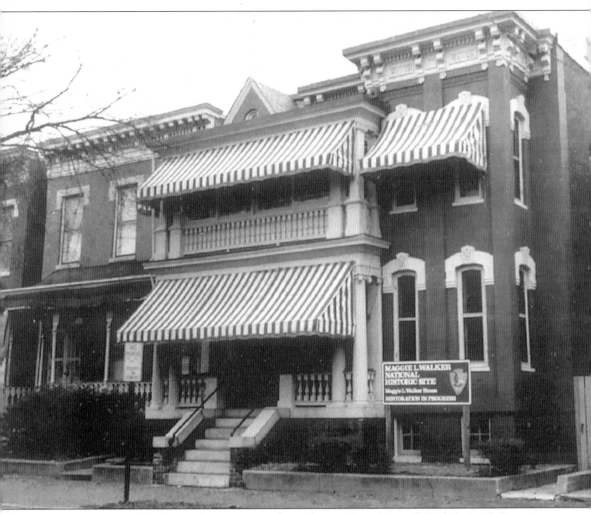

The Maggie L. Walker National Historic Site, shown here, is located at 110 1/2 East Leigh Street in Jackson Ward. Owned and operated by the National Park Service, the site offers guided tours of Maggie L. Walker's former home. (Photograph by Theodore S. Holmes.)

This building, located at 526 North Second Street, is owned by the Elks Lodge. It was originally built in the early 1900s as a mansion for the Rev. W.L. Taylor, who headed the True Reformers after the death of the Rev. William Washington Browne. The building was designed by African-American architect J. A. Lankford.

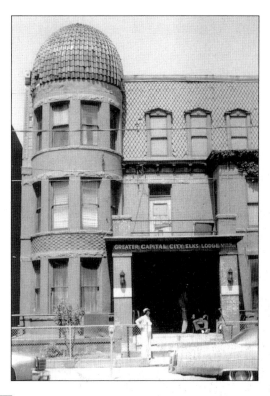

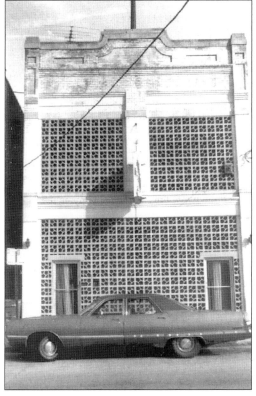

This building was formerly the home of the American Beneficial Insurance Company. It is located in the 600 block of Second Street. (Courtesy of Virginia Department of Historic Resources.)

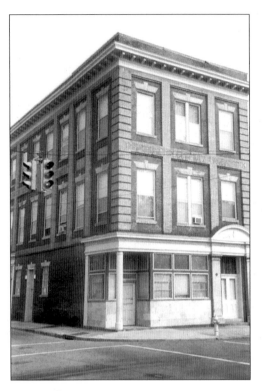

This is the former home of the Richmond Beneficial Insurance Company. The building, located at the intersection of Second and Jackson Streets in Jackson Ward, was designed by African-American architect Charles T. Russell. (Photograph by Elvatrice Belsches.)

This building was formerly the Second Street Savings Bank. It was designed by African-American architect Charles T. Russell and built by African-American contractor D.J. Farrar. Organized in 1920, the bank merged with the St. Luke Bank and Trust Company in 1930 to form the Consolidated Bank & Trust Company. (Photograph by Elvatrice Belsches.)

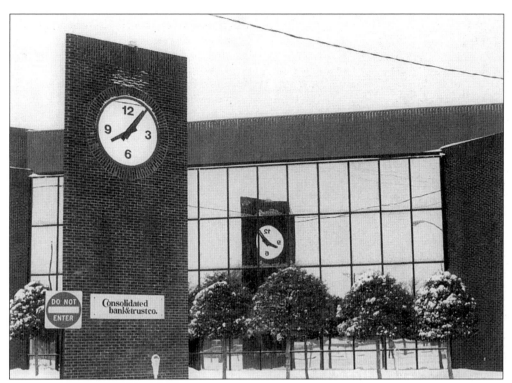

The Consolidated Bank & Trust Company is presently located in the building shown here. Situated at the corner of First and Marshall Streets, it is the oldest continually run African-American bank in America. (Photograph by Theodore S. Holmes.)

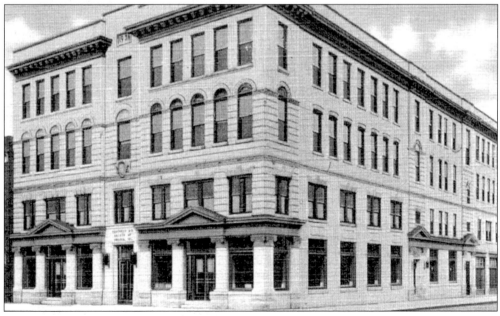

This early postcard portrays the Southern Aid Insurance Building, which is located at the intersection of Third and Clay Streets. (Courtesy of Martha Thompson.)

Many homes in Jackson Ward are adorned with extraordinary ornamental ironwork. An example of such is shown in this image. (Photograph by Theodore S. Holmes.)

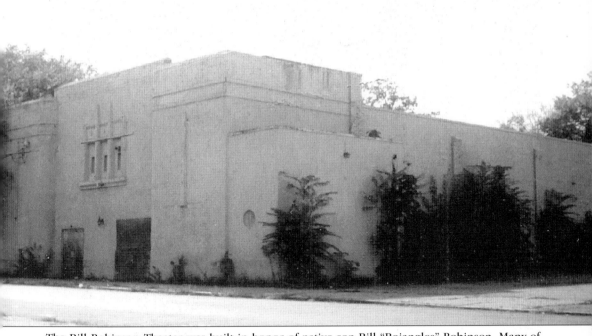

The Bill Robinson Theater was built in honor of native son Bill "Bojangles" Robinson. Many of the elders remember his return for the grand opening. It is located on Q Street between Twenty-ninth and Thirtieth Streets.

SELECTED BIBLIOGRAPHY

Brown Henry. *Narrative of the Life of Henry Box Brown, Written By Himself.* Manchester: Lee and Glynn, 1851.

Bunyon, Arthur, ed. *History of the American Negro* (Virginia edition), Volume Five. Atlanta: A.B. Caldwell Publishing Co., 1921.

Burrell W.P. and D.E. Johnson. *Twenty-five Years History of the Grand Fountain of the United Order of True Reformers, 1881-1905.* Richmond: United Order of True Reformers, 1909.

Ferguson D.A. (David Arthur). *Souvenir Views: Negro Enterprises & Residences, Richmond Virginia.* Richmond: D.A. Ferguson, 1907.

Hartshorn, W.N. and George W. Penniman, eds. *An Era of Progress and Promise, 1863-1910. The Religious, Moral and Educational Development of the American Negro Since His Emancipation.* Boston: The Priscilla Publishing Co., 1910.

Jackson, Luther Porter. *Free Negro Labor and Property Holding In Virginia, 1830-1860.* New York: D. Appleton-Century Co., 1942.

——. *Negro Office-Holders in Virginia, 1865-1895.* Norfolk: Guide Quality Press, 1945.

——. *A History of the Virginia State Teachers Association.* Norfolk: The Guide Publishing Co. Inc., 1937.

Potterfield, Thomas Tyler Jr. "Charles Russell (1875-1952): Virginia's Pioneer African-American Architect." *The Architecture of Virginia.* Richmond: Virginia Commonwealth University, 1994.